THE IMPOSSIBLE MUSEUM

THE BEST ART YOU'LL NEVER SEE

Front cover (from left to right, from above to below): Paul Cézanne, *The Boy in the Red Waistcoat,* see p. 181; after Leonardo da Vinci, *Leda and the Swan,* see p. 22; Gustav Klimt, *Philosophy,* see p. 98 ; Unknown, *The Council of Constantinople,* detail, see p. 132/133; Diego Velázquez, *Las Meninas,* detail, see p. 54; François Boucher, *The Sleeping Shepherd,* detail, see p. 97; The Buddhas of Bamiyan, see p. 81; Tracey Emin, *Everyone I Have Ever Slept With,* detail, see p. 112/113 (© VG Bild-Kunst, Bonn 2012); Christo, *Surrounded Islands,* detail, see p. 38 (© Christo 1983)

© 2012 olo.éditions, Paris

© for the English edition: Prestel Verlag, München · London · New York, 2012

Credits on page 192

Library of Congress Control Number 2012939403;
British Library Cataloguing-in-Publication Data: a catalogue record for this book is available from the British Library;
Deutsche Nationalbibliothek holds a record of this publication in the Deutsche Nationalbibliografie; detailed bibliographical data can be found under: http://dnb.d-nb.de

Prestel books are available worldwide. Please contact your nearest bookseller or one of the above addresses for information concerning your local distributor.

Prestel Verlag, Munich
A member of Verlagsgruppe Random House GmbH

Prestel Verlag
Neumarkter Strasse 28
81673 Munich
Tel. +49 (0)89 4136-0
Fax +49 (0)89 4136-2335

Prestel Publishing Ltd.
4 Bloomsbury Place
London WC1A 2QA
Tel. +44 (0)20 7323-5004
Fax +44 (0)20 7636-8004

Prestel Publishing
900 Broadway, Suite 603
New York, NY 10003
Tel. +1 (212) 995-2720
Fax +1 (212) 995-2733

www.prestel.com

Editorial direction: Claudia Stäuble, Franziska Stegmann
Translated from French: Philippa Hurd
Copyediting: Chris Murray
Layout: Torsten Köchlin, Berlin
Cover: Stefan Schmid Design, Stuttgart
Typesetting: textum Gmbh/Christine Rehmann
Production: Nele Krüger
Art direction: Cilly Klotz
Printing and Binding: Tien Wah Press

Printed in Singapore

Verlagsgruppe Random House FSC-DEU-0100
The FSC-certified paper *Titan MA* produced by mill Janghang has been supplied by Hansol Paper Co., Korea.

ISBN 978-3-7913-4715-8

Céline Delavaux

THE IMPOSSIBLE MUSEUM

THE BEST ART YOU'LL NEVER SEE

PRESTEL Munich · London · New York

Paintings, sculptures, tapestries, manuscripts, and jewels have all managed to journey down the centuries, traveling from one continent to another, often outliving the very civilizations that created them. Museum visitor usually take this for granted. But works of art carry within them histories that are often turbulent, and in *The Impossible Museum: The Best Art You'll Never See* it is the adventures and misadventures that have befallen various works that tell the story of the survivals and losses that define our artistic heritage.

The history of art is full of ghosts. And some of them, paradoxically, are more famous and more precious than many of the works that reside in serene and discreet splendour in our museums. It is this hidden face of art that *The Impossible Museum: The Best Art You'll Never See* intends to reveal. We have created several departments in our 'imaginary museum' to welcome these lost works: works that have disappeared, been transformed, destroyed, hidden, or stolen.

Some artworks, though they have not survived the passage of time, have, thanks to life-saving copies, been preserved as memories. This is the case, for example, with many sculptures from Ancient Greece. Sketches by the great masters also provide

evidence of the existence of masterpieces that have never reached us. Other, much more recent, works have not been preserved quite simply because they were never intended to be. This being so, all the works of Christo and Jeanne-Claude would deserve a place in *The Impossible Museum: The Best Art You'll Never See*! Priceless manuscripts and jewels appear in museum collections but in a different form from how they were originally made. Paintings and sculptures have been altered by a sudden event or by the artists themselves and, thus transformed, have embark upon a second life. Science has revealed that behind one familiar painting there often lurks another. Some works of art, by contrast, have been irretrievably destroyed by an accident or even by censorship. Here again, copies or photographs have made possible a ghostly existence that continues to haunt our imaginations. Other works do exist but might be too delicate for public viewing, and so are kept hidden in storerooms; or, rare and very expensive, are reserved for a privileged few, being kept closely guarded in private warehouses, locked up in bank vaults, or even displayed in exclusively private spaces. Finally, many works of art are the targets of theft. But this kind of disappearance at least makes it conceivable that one day they will leave our 'virtual museum' and once again inhabit a museum that is more real than imaginary.

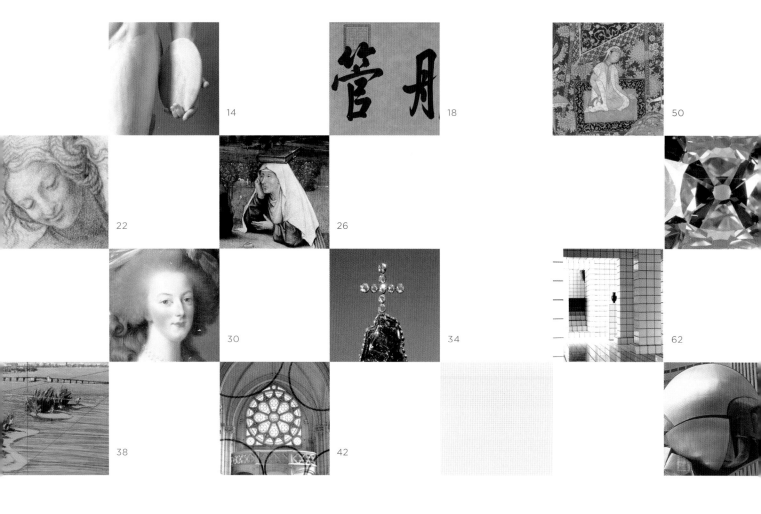

DISAPPEARED

TRANSFORMED

DESTROYED

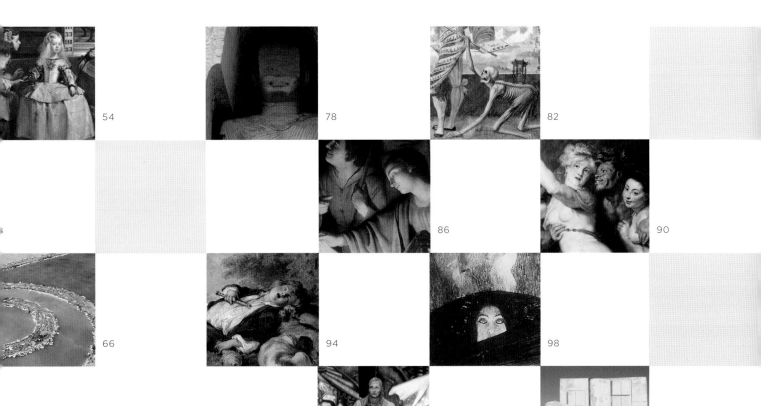

54 78 82 86 90 66 94 98 102 106

110

HIDDEN

STOLEN

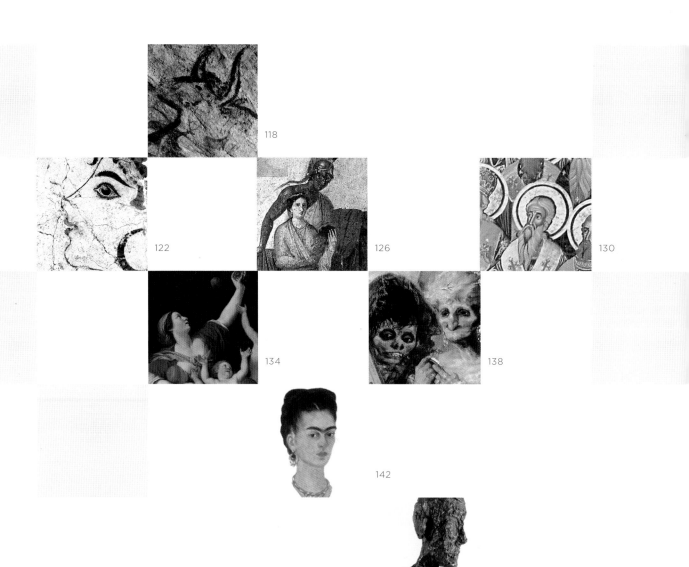

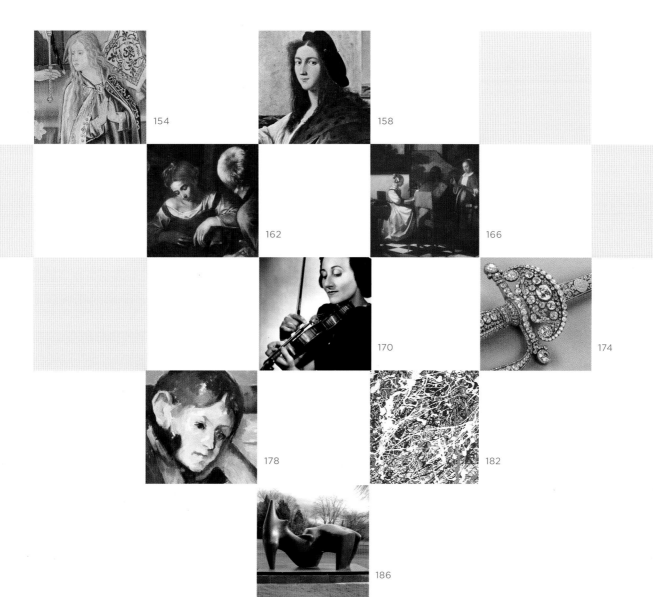

DISAPPEARED

When the word 'copy' is mentioned in the art world today, the first thing people think of, more often than not, is 'fake,' and then 'scandal.' Barely a week goes by without the press breaking a new story of forged works of art. Talking of a 'copy' conjures up images of talented forgers working in secret and of disreputable dealers, of the darker side of the international art market.

But in the context of our 'imaginary museum', we should instead be more inclined to praise the copy. For without the copy we would have a much more fragmentary knowledge of the art of Antiquity. Thanks to the copy, missing works of art have managed to travel down the ages to be with us today. In retrospect, we should be pleased that the Romans copied so much Greek art, and that the imitating of the master artists of Antiquity was an essential step in an artist's career. Making copies was a kind of apprenticeship; or, rather, an act of homage to previous masters. In this context, copying was far from being seen as dishonest or criminal. For reasons not entirely to do with the passage of time, some works of art, while less fragile than antique ceramics or Renaissance paintings, vanished into thin air after enjoying some incredible adventures. This is the case with royal jewels, created using highly specialized craftsmanship, and made with materials whose 'recycling' created irresistible temptations.

By contrast, certain works of modern and contemporary art were meant to disappear. Self-destruction was the ultimate aim of *Homage to New York,* a work created by the Swiss artist Jean Tinguely in 1960—a random collection of machines that were programmed to explode after 28 minutes of frenetic activity. Their ephemeral nature is shared by other works of art, such as most works of Land Art and all pieces of Performance Art. When in 1971 artist Chris Burden made himself the target of a rifle, the work, titled *Shoot,* was impossible to preserve, beyond the doubtless unforgettable memories of those who witnessed this 'happening.' And how do you exhibit or conserve *The Great Wall Walk* by the Serbian artist Marina Abramović, which consisted of her walking up and down the 2,000 kilometers (1,240 miles) of the Great Wall of China in 1988?

These new artistic practices, which emerged in the 1960s, question the definition of the work of art, the status of the artist, and the role of the museum. Art is no longer typically the canvas, palette, and the four walls of the artist's studio. Today preparatory sketches, writings by artists or critics, and of course photographs of these ephemeral works, have become crucial (and indeed very valuable) pieces of evidence. The work of art may have vanished, but it still exists.

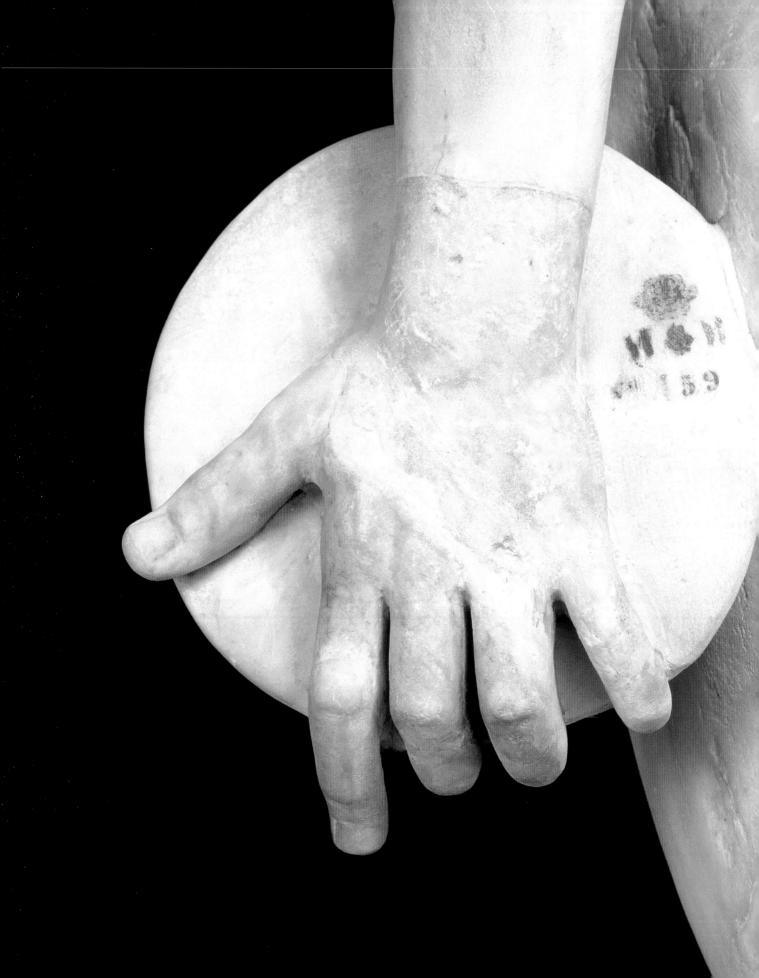

NAUCYDES OF ARGOS
DISCOPHOROS

c. 390 BC

Superb athletes with perfectly proportioned bodies—this skillful harmony in search of an ideal of 'beauty'—characterize Greek art in its so-called classical period. However, with rare exceptions, the statues that populate the antiquities galleries in our museums were made, or more precisely copied, by the Romans.

The disappearance of the thousands of sculptures that once adorned the cities of Ancient Greece has a very mundane explanation: the bronze from which the sculptures were cast was melted down to make weapons or possibly tools and even household utensils. The marble the Romans used for their copies of Greek statuary escaped this insensitive recycling.

After Naucydes of Argos, *Discophoros* (detail), Roman Empire, sculpted marble, height: 167 cm, Louvre Museum, Paris, France

By way of anatomy classes, Greek artists studied sportsmen
as they exercised in order to learn the forms of the human body.
Placed in gymnasiums, the statues served in turn as demonstration
models for young athletes.

At first the pragmatic Romans were skeptical of a people who revered the theater as much as politics, who devoted so much time to philosophy, and who considered the athlete to be the equal of the soldier. But at the same time the Romans greatly admired Greek culture. From the 2nd century BC onwards, Rome welcomed Greek artists and thinkers, while young, well-to-do Romans were sent to Greece to study and their parents ordered copies of Greek masterpieces from artists and craftsmen. As a result, only a few names of Roman sculptors, who were mainly slaves or freedmen, are known to us.

Above all it is the classical Greek period that had the greatest influence on Roman statuary. In the 5th century BC the Greek sculptor Polykleitos drew up the rules of a famous treatise that were followed by his young disciple Naucydes of Argos. The musculature of Naucydes's athlete is formed of solid, well-defined masses. It recalls the harmony of the ideal anatomies in sculptures by Polykleitos and Myron of Eleutherae, which were governed by a skillful calculation of proportions. But Naucydes outstripped the teachings of his masters: he absorbed their lessons and acquired a perfect mastery of anatomy, but we can also see in the features of his athlete a concentration and tension *inside* the body. As a result, Naucydes chose to represent his athlete before the action started. In this, he goes beyond his predecessors: he shows the athlete as he is preparing to throw the discus, not while throwing it. And the name of the sculpture gives the clue: the *discophoros* is the man who holds the discus, not the one who throws it.

Today there remain several Roman copies that we can recognize as replicas of the work Naucydes created in bronze—an original now lost that was perhaps sadly fated to be melted down.

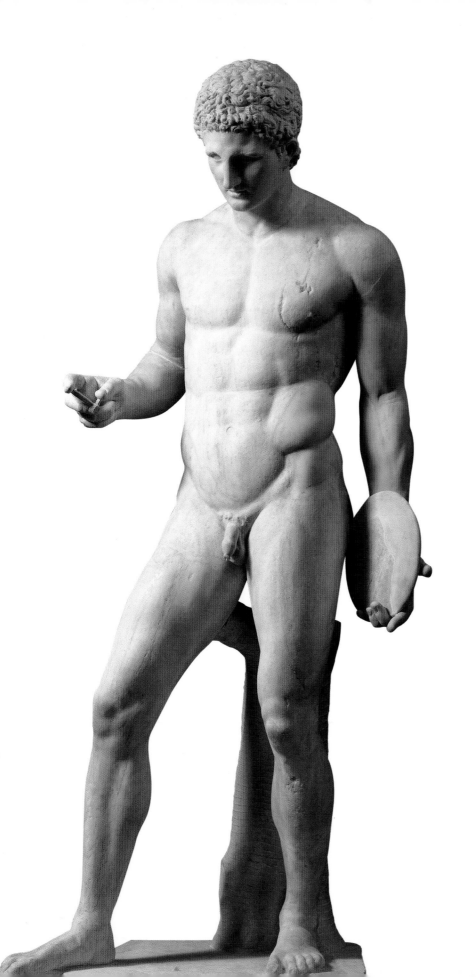

After Naucydes of Argos,
Discophoros, Roman Empire,
sculpted marble,
height: 167 cm,
Louvre Museum, Paris,
France

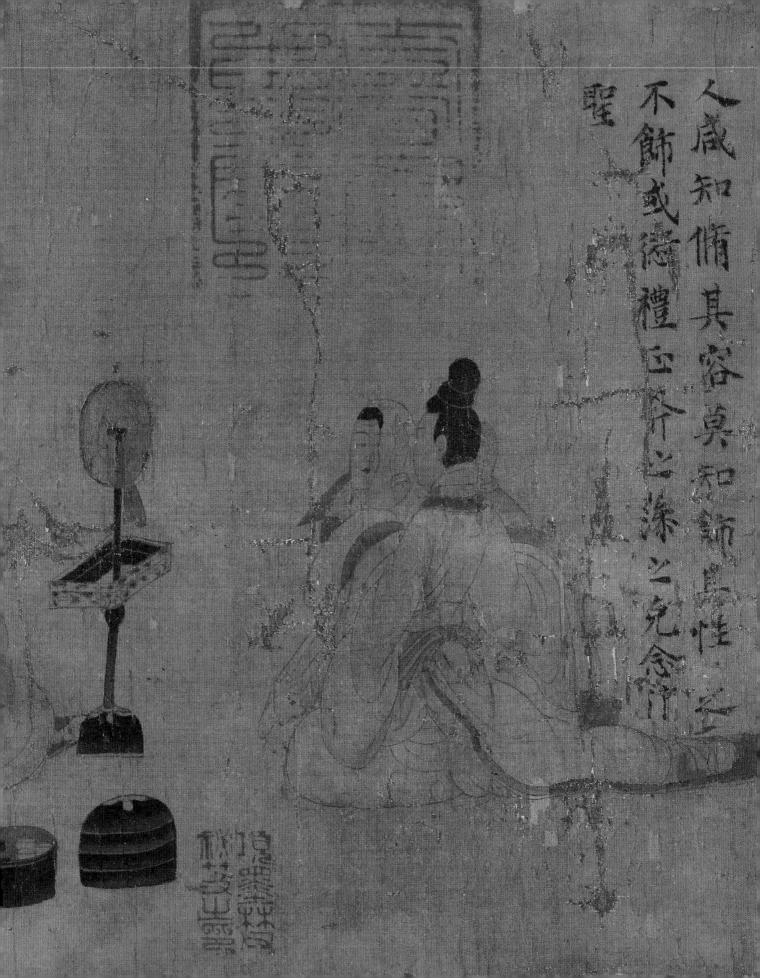

人咸知脩其容莫知飾其性
不飾或愆德禮正斧之藻之念
聖

GU KAIZHI
ADMONITIONS OF THE INSTRUCTRESS TO THE COURT LADIES

c. 344–406

In the 4th century AD, when the famous Chinese artist Gu Kaizhi started to take an interest in literary texts, he transformed them into works of art. The *Admonitions of the Instructress to the Court Ladies*, a work of painting and calligraphy on a silk scroll, has been copied and annotated by other painters or collectors over several centuries. It is through this invaluable evidence that we know about Gu Kaizhi, one of the very first great Chinese artists.

After Gu Kaizhi, *Admonitions of the Instructress to the Court Ladies* (detail), 8th century, chinese ink, color, painting on silk, height: 343 cm, British Museum, London, Great Britain

The famous scroll *Admonitions of the Instructress to the Court Ladies*, an early copy of the original, was passed around between various great collectors before arriving in the Imperial Collection in Peking in the 18th century. Here in 1900 it was stolen by a British army officer who three years later sold it to the British Museum.

If the name of Gu Kaizhi still survives today it is first of all because of the period during which he worked. From the 4th century AD China began to emerge from the so-called 'ancient era' of its history, during which its artistic production had remained craftwork and anonymous. With the advent of the dynasties, artists, who came from a social and intellectual elite, became well known. But Gu Kaizhi's continued fame is also doubtless due to his remarkable temperament: the painter charmed people with his sophisticated repartee and a touch of eccentricity, which was perhaps why he managed to live through a succession of troubled dynasties without apparent difficulties. His frescoes drew the crowds in the Buddhist temples, the skill of his portrait paintings aroused admiration, and his illustrations to literary texts circulated throughout the kingdom.

The silk scroll kept at the British Museum is said to be a copy of one of Gu Kaizhi's illustrative works. The original

This silk scroll, which has been restored and patched many times, has survived for over 1,200 years, as the traces of the seals affixed by its collectors bear witness. As it was an exact replica, this ancient copy is no less a treasure of Chinese painting.

drew on a satirical text written by Zhang Hua in the 3rd century AD that came from a tradition of morality tales. At that time, the princes were accustomed to displaying portraits of virtuous women in their palaces to serve as models, and the empresses drew up rules for how women should behave. In this tale the writer has given this role to an instructress whom Gu Kaizhi depicts at the end of the scroll, as if she were the author of the text. These admonitions, addressed to the emperor's concubines, were originally shown over 12 episodes, but this copy of the scroll, dating from the 8th century, contains only nine. Gu Kaizhi's calligraphy proceeds in sequences that are illustrated by the depiction of exemplary conduct: one

concubine risks her life by placing herself in the path of a bear that has escaped from a menagerie and is now threatening the emperor; another declines the invitation to share the emperor's palanquin or sedan chair in the interest of virtue. Modesty of feeling rather than the wiles of seduction are thus recommended to those who want to retain the emperor's favor.

After Gu Kaizhi, *Admonitions of the Instructress to the Court Ladies*, 8th century,
chinese ink, color, painting on silk, height: 343 cm,
British Museum, London, Great Britain

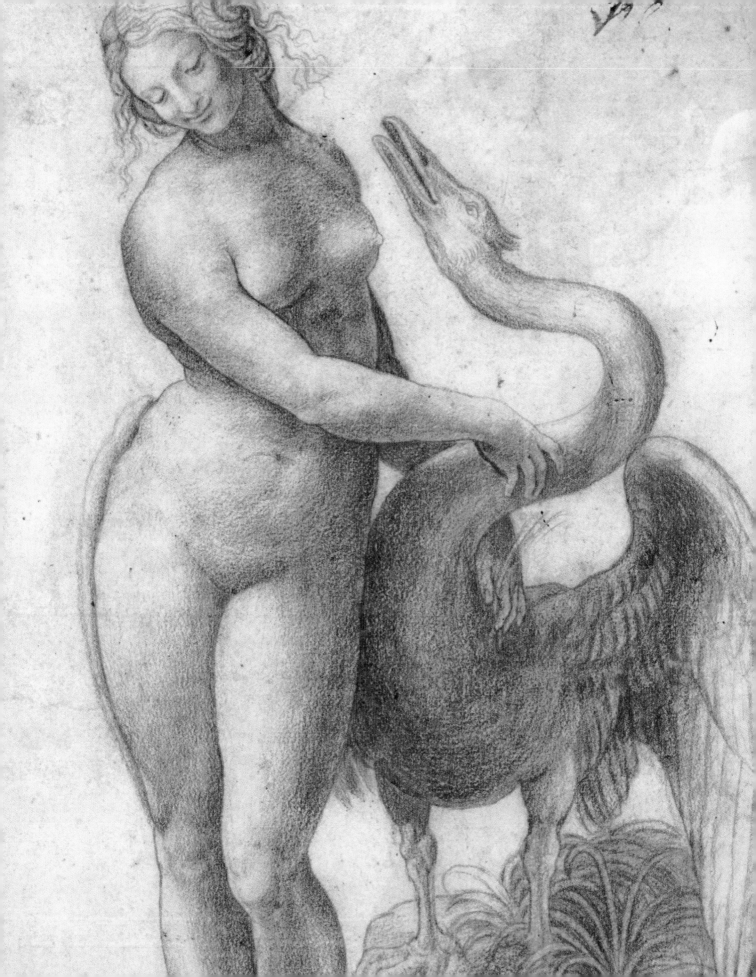

LEONARDO DA VINCI
LEDA AND THE SWAN

1452–1519

For cultivated men during the Renaissance in Italy, the very name of Leda conjured up a woman of remarkable beauty. Leonardo da Vinci was one of the first artists to make her the main subject of a work of art—a work whose mysterious disappearance has only intensified the legendary sensuality of the subject.

Research into missing works of art often takes on the appearance of a police investigation, particularly when the supposed author of the work was Leonardo da Vinci. This great Renaissance master is said to have painted two different versions of *Leda and the Swan*, but art historians have to make do with studying copies of these original paintings, which have been lost for several centuries.

After Leonardo da Vinci, *Nude, Standing Leda, Caressed by the Swan*, red chalk, 27.2 x 16.8 cm, Louvre Museum, Paris, France

Cesare da Sesto (?) after
Leonardo da Vinci,
Leda and the Swan, 1510–1515,
oil on canvas, 112 x 86 cm,
Galleria Borghese,
Rome, Italy

Leda hesitates, caught between the memory of the swan's embrace
(the swan is Zeus after all!) and her maternal instincts,
which burgeon when she sees her newly hatched children.

In Greek mythology, Leda, wife of the king of Sparta, is said to have been seduced by Zeus, who had transformed himself into a swan. As a result of this amorous encounter two eggs produced two sets of famous twins: Castor and Pollux, Clytemnestra and Helen of Troy. From the 4th century onwards, the Greeks depicted this myth in sculptures that were still to be seen in Renaissance collections of Roman art. These ancient works of art, as well as Ovid's *Metamorphoses*, served as Leonardo's sources of inspiration. The latter's paintings may have vanished but there are nevertheless preparatory studies by Leonardo himself, and copies on which art historians have been able to base their research. First, some simple sketches of 1504 (now in the Royal Library of Windsor Castle in England) offer various clues to the existence of the painting; they show Leda alone and kneeling. Next, the discovery of two drawings that show the addition of plants and the swan leads us to think that here Leonardo was making preparatory studies for a painting of Leda. The first drawing shows Leda turned towards the swan, with a hatched egg nearby. In the second, two eggs are shown hatched and Leda appears to be getting up. Between 1505 and 1507, Leonardo continued to work on the image of Leda standing in three very quick sketches that inspired the painting (Uffizi Gallery in Florence) that survives only in a 1510–1513 version by a workshop assistant. A witness reported that the original could be found in the Palace of Fontainebleau in 1625: the painting would thus have belonged to King Francis I who, let us remember, at one time owned the *Mona Lisa*. In 1692 the painting was still listed in Fontainebleau's inventories. Then it vanished. A variation on the same scene, which was long attributed to Leonardo, can today be seen at the Galleria Borghese in Rome. But this is in fact a copy that has been linked to a red-ink drawing in the Louvre in Paris. However, this drawing too is nothing more than a pale imitation of the lost work of art. Leonardo undoubtedly did paint Leda, but we will never see it.

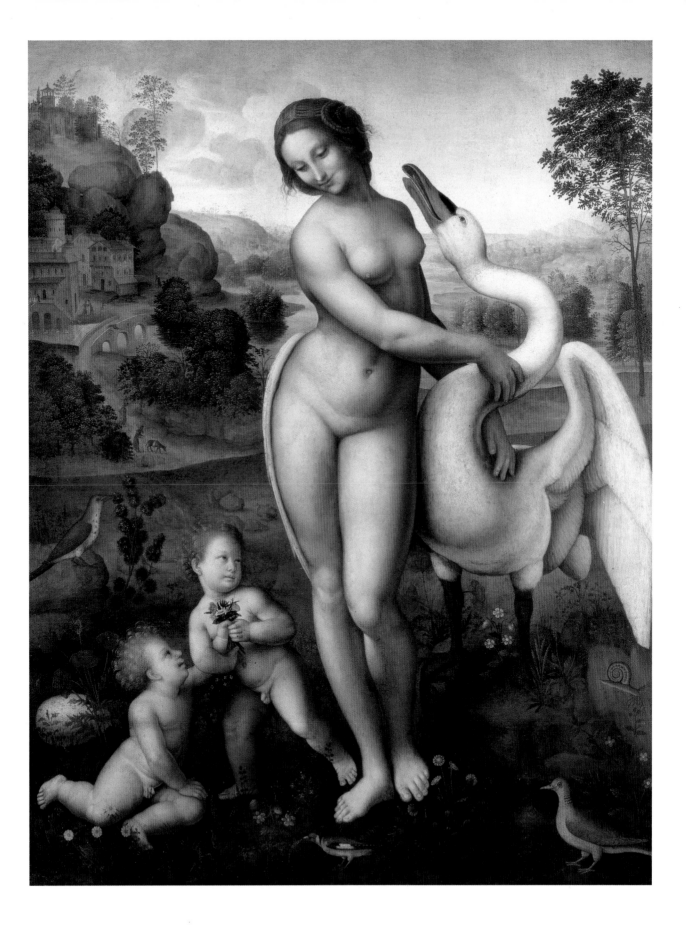

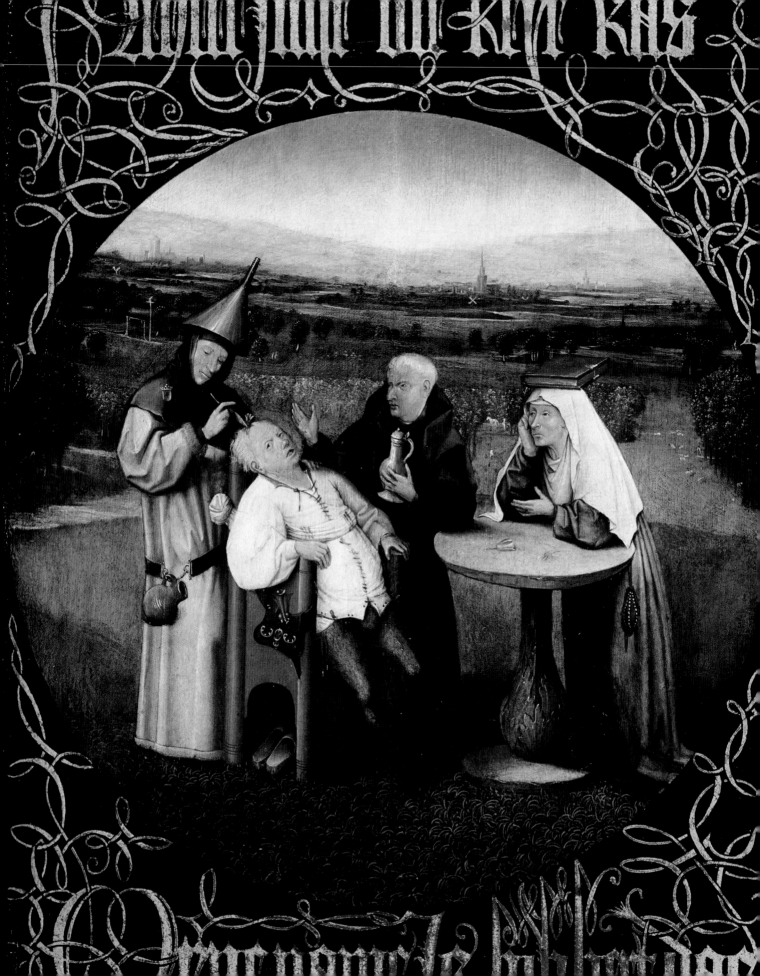

PIETER BRUEGEL THE ELDER
CUTTING OUT THE STONE OF MADNESS

c. 1525/30–1569

During his lifetime, copies of Hieronymous Bosch's works proliferated throughout Europe, such was his popularity among Humanists. Pieter Bruegel fitted so easily into Bosch's sphere of influence that he was called 'the other Bosch.'

If Pieter Bruegel was freely inspired by a painting created by his predecessor Hieronymus Bosch, by contrast the version we have of Bruegel's *Cutting out the Stone of Madness* is probably an exact copy painted by one of his contemporaries. Today doubts have been cast even on the authenticity of Bosch's painting, titled *Extracting the Stone of Madness* (*c.* 1490), which is in the Prado Museum in Madrid, but there is no doubt at all that Bruegel's work has vanished.

Hieronymous Bosch, *Extracting the Stone of Madness,*
c. 1490, oil on panel, 48 x 35 cm,
Prado Museum, Madrid, Spain

After Pieter Bruegel the Elder,
*Cutting out the Stone of
Madness or An Operation
on the Head,* 16th century,
oil on panel, 77 x 107 cm,
Palugyan Collection,
Hôtel Sandelin Museum,
Saint-Omer, France

Bruegel would first have made a drawing on the theme freely inspired by Bosch; there is an anonymous engraving inscribed "Bruegel *inventor* 1557" (which identifies him as the artist who created the design for the print). At the beginning of the 20th century, a German art historian published poor-quality photographs of a painting that showed the same scene as this print, and that he attributed to Bruegel. This original painting moved between different collections in Budapest before vanishing. Thus *Cutting out the Stone of Madness*, which was acquired by the Hôtel Sandelin Museum in Saint-Omer in France in 1881, is thought to be an old copy of a missing original.

Several engravings and paintings in the Flemish School from the 15th to the 17th centuries depict this alarming 'operation on the head,' to quote the subtitle of Bruegel's work. During this period, conventional wisdom actually attributed insanity to the presence of a stone in the head: the expression 'having a stone in your head' meant 'being insane.' Renaissance writers and painters were fascinated by insanity and took it up as a subject in Humanist philosophy. When Bruegel seized on the theme, he was claiming that his contemporaries were too credulous to think rationally, or to free their intellect from popular beliefs and superstitions. He takes up Bosch's theme and adds many new details. Inevitably the viewer of the painting wonders who, out of the quack surgeon and the hapless patient, is the real madman. The scene in no way evokes the seriousness demanded by the practice of medicine, but rather a barbarous and generalized insanity.

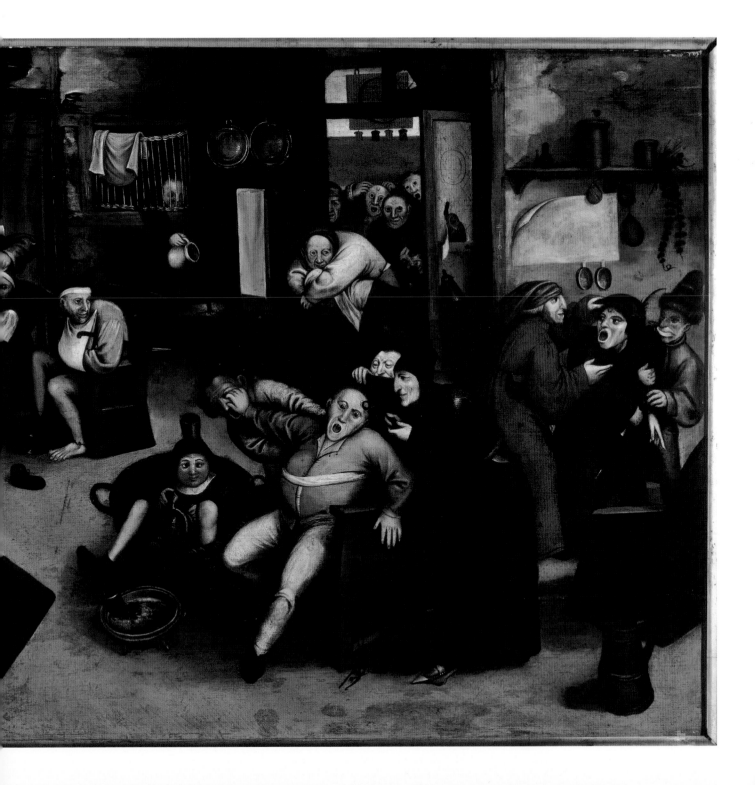

BOEHMER AND BASSENGE
THE QUEEN'S NECKLACE

18th century

The elegant Queen Marie-Antoinette was famous for her legendary passion for jewels, and the infamous fraud of the 'Queen's Necklace' played on this reputation. This extraordinary affair further discredited royal power just four years before the revolutionary events of 1789.

Made around 1773 by French crown jewelers Boehmer and Bassenge, the 'Queen's Necklace' was in fact never worn by Marie-Antoinette. From the start it was handed over to con men who sold the stone to Belgian diamond dealers and jewelers in London. A zircon replica is on view today at the Château de Breteuil, which was owned at the time by the government minister who discovered the fraud and arrested the main suspect, Cardinal de Rohan, in 1785.

Louise Élisabeth Vigée-Le Brun, *Marie Antoinette with the Rose,*
1783, oil on canvas, 113 x 87 cm,
Petit Trianon, Palace of Versailles, France

For almost one hundred years, up until the end of the 19th century,
the descendants of Cardinal de Rohan were still
reimbursing the heirs of one of the jewelers.

In creating this sumptuous necklace, which was set with 647 jewels and weighed 2,300 carats in total, the jewelers were taking a great risk. They originally made the necklace for the Countess du Barry, a favorite of King Louis XV, but the king died in 1774 before she was able to acquire it. In 1778 they offered the jewels to the new queen, but in spite of her reputation as a frivolous spendthrift Marie-Antoinette was astonished by the price of the necklace—an astronomical 1,600,000 *livres*!

In 1784 Cardinal de Rohan, who was trying to get back into the queen's favor, was approached by the scheming Countess de la Motte-Valois. She claimed to be an intimate friend of Marie-Antoinette's and promised the cardinal that she could effect a reconciliation. With the help of accomplices she sent the cardinal faked letters purporting to be from the queen, and even organized a brief nighttime rendezvous with a double playing the role of Marie-Antoinette. Finally she confided in the cardinal that the queen wanted a lavish necklace that she could not in all decency acquire for herself, but which he could buy in her name. The cardinal accepted the task, and took delivery of the jewels, which he sent to the queen through the mediation of a man disguised as a valet. But several months later the jewelers demanded their payment directly from an incredulous Marie-Antoinette, who ordered the Baron de Breteuil to resolve the matter. Cardinal de Rohan was unmasked. When he learned of the scandal, Louis XVI had the cardinal arrested in order to clear the queen's name, choosing August 15, 1785, a feast day at Versailles, for this very public display of royal displeasure. As a result of the trial, the Countess de la Motte-Valois was found guilty, branded with the letter V for *voleuse* (thief), and imprisoned in the Salpêtrière (a lunatic asylum cum prison in Paris). By contrast, parliament acquitted the cardinal of any wrong doing, but agreed that he owed the jewelers money. The public regarded this verdict as proof of the queen's guilt; no one held it against the cardinal for acquiring the jewels in the belief that Marie-Antoinette would offer him sexual favors behind the king's back. In this case the queen's unfavorable reputation was cruelly and unjustly confirmed.

After Boehmer and Bassenge, *Queen Marie-Antoinette's Necklace*,
18th century, Château de Breteuil, France

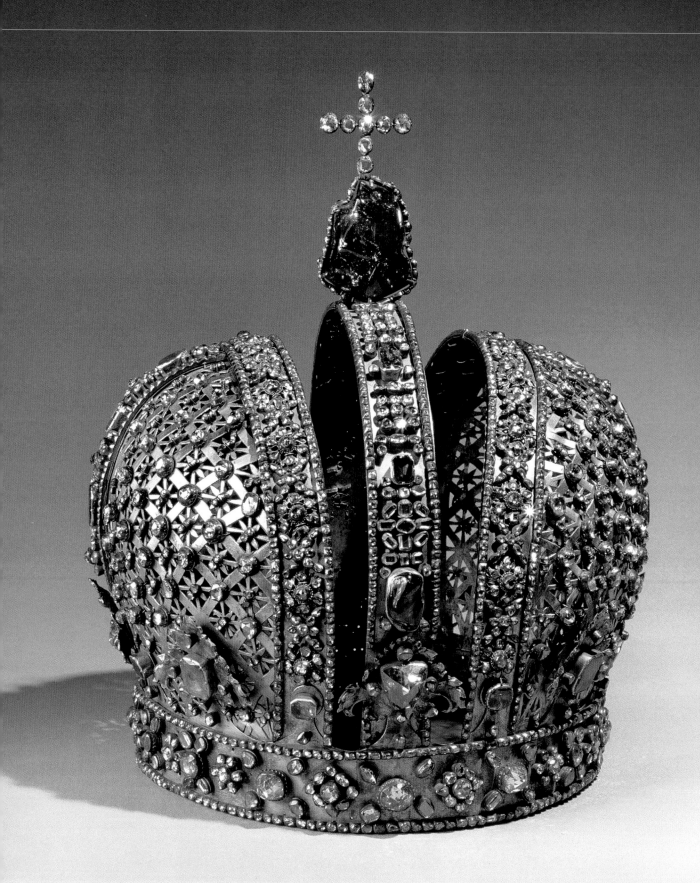

THE ROMANOV JEWELS

Descendants of Ivan the Terrible, the Romanov family provided the tsars and tsarinas of Russia from the beginning of the 17th century until 1917. Over the course of their reign they amassed the most fabulous collection of jewels in the world. The jewels of the last Russian dynasty are testament to the incredible splendor of this royal line.

The history of the Romanov Jewels, which can easily be compared with the extravagant life of those who wore them, was one of epic, tragic, and, more recently, almost comic adventures and misadventures. When the dynasty lost power in 1917, most of their jewels disappeared with them.

Russian School, *Crown of the Empress Anne of Russia,* 1730,
silver, gold, and precious stones,
Kremlin State Armory Museum, Moscow, Russia

The Empress Alexandra
Feodorovna, with her pearl
diadem dating from 1830,
which is still missing

Over a period of 15 days in the spring of 1997, an American truck

carrying the treasures of the Russian imperial court

remained parked on a Washington street,

blocked by two Russian diplomatic vehicles.

When the Bolshevik Revolution broke out in 1917, Tsar Nicholas II abdicated, bringing to an end the last Russian dynasty. The members of the imperial family were placed under house arrest in Siberia, until they were shot on July 17, 1918. It was reported that, at the time of the execution, Alexandra Feodorovna, the wife of Nicholas II, and her daughters were so 'encrusted' with jewels that the bullets kept being deflected before they finally hit their targets. But there is also the story that the empress had given most of her jewelry collection to the nuns of a local convent, and that the latter passed them on to a fishmonger for safekeeping. Fifteen years later the fishmonger was betrayed to the political police, who dug up two large glass jars containing 154 jewels—diamond diadems, brooches, hat-pins... After this discovery in 1933, the jewels vanished once again. But this hidden treasure made up only a small part of the jewels of the imperial court. In fact, since the beginning of the 19th century the Russian tsars had owned the most lavish jewelry collection of all the European royal courts. The source of this wealth came from the precious resources of the Orient and the products of the Siberian mines. Some jewels managed to escape the Revolution, others remained safe in Moscow. This is why a jewelry collection can be seen in the Kremlin Museum in Moscow to this day.

In 1997, however, the first time that the Romanov Jewels were exhibited outside Russia, the story turned into a diplomatic wrangle. After being shown at the Corcoran Gallery in Washington, DC, the exhibition was meant to go on to the Fine Arts Museum in Houston, Texas. But then the Russian government, unhappy with the security arrangements, asked for the return of its collections. The treasures of the Russian imperial court were thus taken hostage for 15 days while negotiations tried to put an end to this new kind of Cold War.

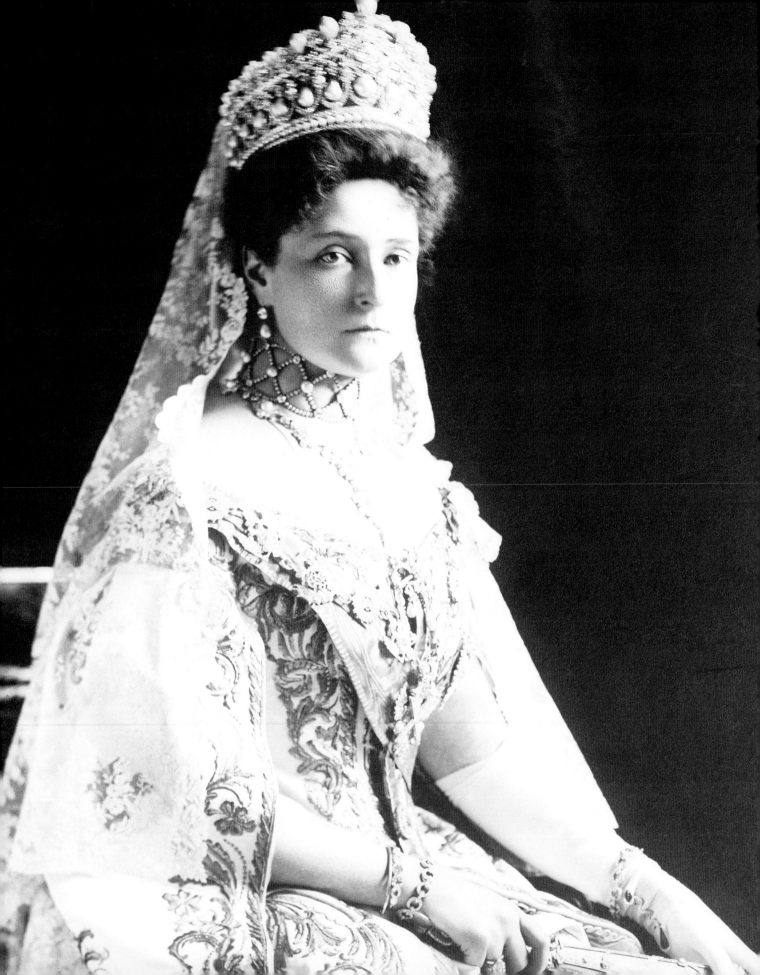

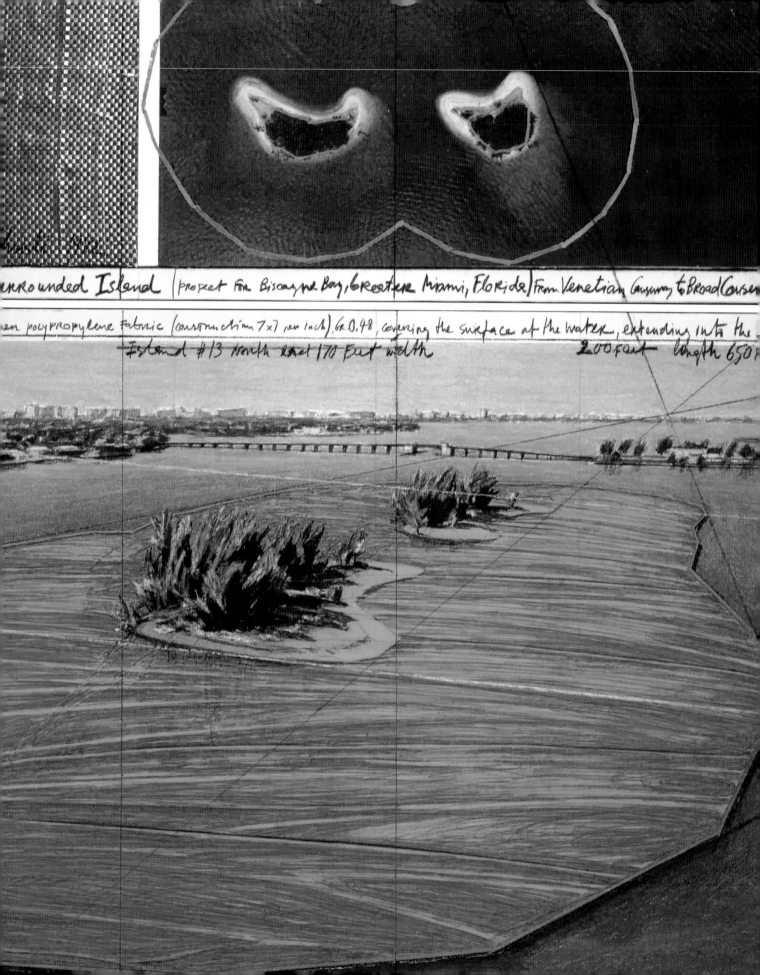

rrounded Island (project for Biscayne Bay, Greater Miami, Florida) From Venetian Causeway to Broad Causew

n polyPROPYLene fabric (construction 7x7 per inch), Gr. 0.48, covering the surface of the water, extending into the

Island #13 North east 170 feet width 200 feet length 650

CHRISTO AND JEANNE-CLAUDE
SURROUNDED ISLANDS

1935– and 1935–2009

The power of Christo and Jeanne-Claude's work derives from the contrast between spectacular, monumental form and an ephemeral lifespan. Some viewers had the opportunity to admire them *in situ*, during the time they were exhibited. Others have to make to with photographs of the works and Christo's superb preparatory sketches.

In May 1983 the islands in Biscayne Bay near Miami underwent an extraordinary transformation. Wrapped in fuchsia-pink, which chimed very well with their own green color, the islands seemed to parade around the turquoise waters of the Atlantic as if ballet dancers. Like all their projects, Christo and Jeanne-Claude's *Surrounded Islands* took many long years of preparatory work—three years of preparation for just two weeks of existence.

Christo, *Surrounded Islands,*
two-part collage, pencil, fabric, pastel, graphite, wax,
paint, and aerial photograph, 1982,
28 x 71.1 and 55.9 x 71.1 cm, Private collection

Sometimes Land Art can help the landscape to re-claim its rightful character in a spectacular way. Before Christo and Jeanne-Claude wrapped these artificial islands in a candy-pink covering, they were being used as garbage dumps.

Since the 1950s Christo and Jeanne-Claude have been wrapping the world around them in fabric: in 1968 they wrapped the Museum of Contemporary Art in Chicago, in 1970 the rocks on a stretch of the Australian coastline, the Pont-Neuf in Paris in 1985, and the Reichstag in Berlin in 1995, among many other sites. The artists can sometimes wait more than ten years before their ideas comes to fruition, particularly since the cost of realizing such works is immense.

Like any 'traditional' artist, Christo begins by making sketches in his studio. He outlines several views of his project, working in the manner of an architect. Then he pins his drawings on large boards that he further embellishes with notes, topographical maps of the region where the installation will appear, and samples of fabric that will wrap the chosen monument or site. These preparations constitute fully fledged works of art in themselves, which, when sold at auction, reach astronomical prices and so contribute to the financing of the final major work.

To wrap the eleven islands in Miami bay, Christo and Jeanne-Claude came up against numerous administrative and technical problems. In April 1981 they hired a team of lawyers, engineers, a contractor, a specialist in marine biology, ornithologists, and a zoologist. They rented a factory for several months in order to assemble the 603,870 square meters (6.5 million square feet) of floating pink fabric needed to match the contours of the islands. On May 4, 1983, hundreds of technicians lashed the pink polypropylene fabric to the islands, and on May 7 the work of art finally looked exactly as the artists had imagined it three years earlier.

Christo and Jeanne-Claude, *Surrounded Islands*, 1980–1983, 603,870 square meters of pink fabric (woven polypropylene) floating around 11 islands, Biscayne Bay, Miami, Florida, USA

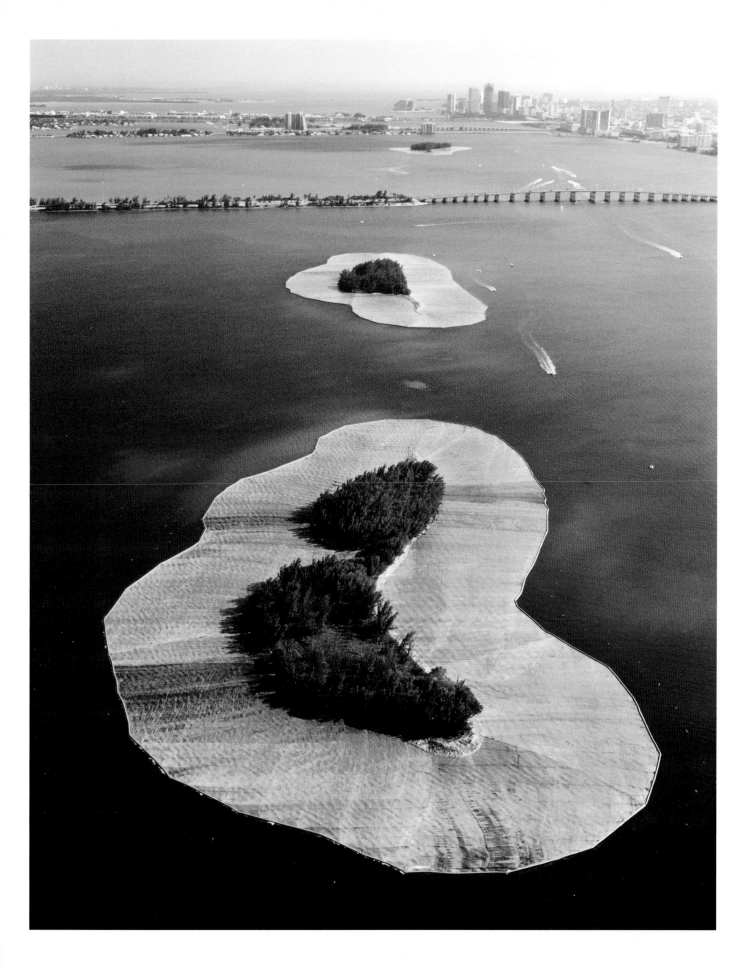

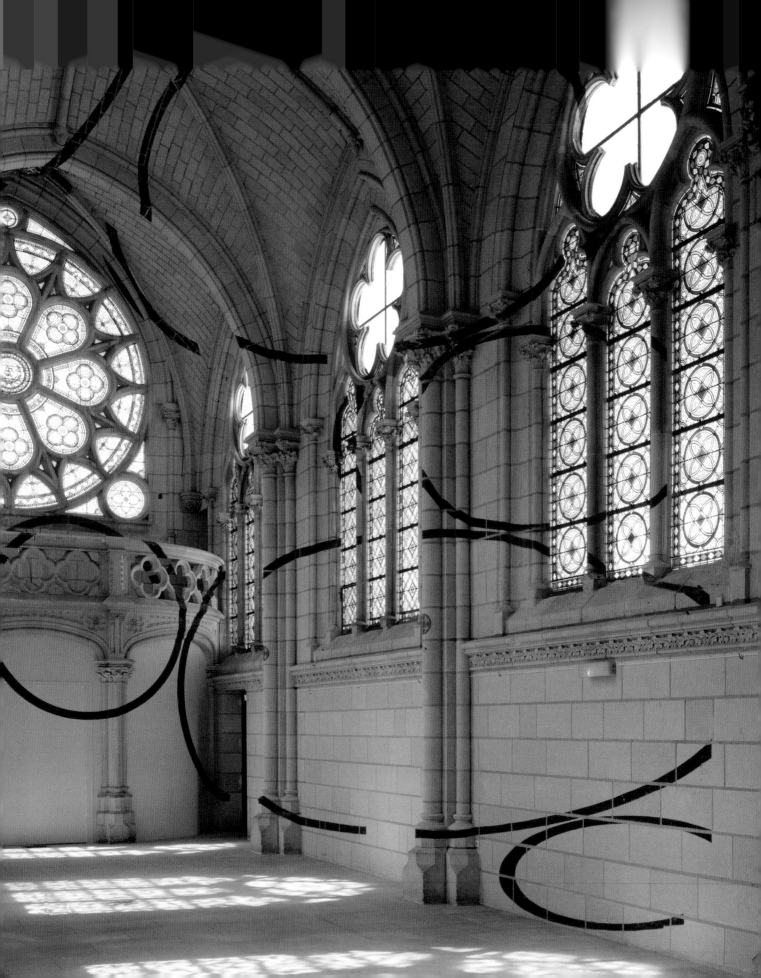

FELICE VARINI
TEN CIRCLES

1952–

When painting abandons the protected context of the canvas and inhabits real space, it often runs the risk of ephemerality. Subject to the vagaries of a living place, site-specific works of art are often not designed to last. And some artists go further: simply stepping to one side or blinking is enough for the viewer to make the work of art vanish.

If Felice Varini defines himself as a painter, it is neverthe-less in a three-dimensional space that he works: a com-plex taking of liberties that also imposes strict constraints on the viewer. Today, the ephemeral work that Varini cre-ated in 1999 in the Chapelle Jeanne-d'Arc in Thouars, France, exists only as photographs. But even when it was exhibited, it was already inclined to vanish for those people who did not adopt the 'correct' point of view.

Felice Varini, *Ten Circles* (viewed off-center), 1999, red chalk, Chapelle Jeanne-d'Arc, Thouars, France

Photography is the ideal medium for capturing Varini's works at the very
moment when the drawing takes the original form imagined by the artist.
But nothing can replace the feelings of discovery and delight that viewers
experience ephemerally *in situ*.

Since the 1980s the Swiss artist Felice Varini has been working on a way of producing images that explores space and architecture. He takes a real location, preserving its forms and lines, and superimposes on it a geometrical drawing, often in a single primary color. Varini uses all the landscape surrounding the location as his 'canvas'—one of his works, created in the port of Saint-Nazaire, extends over more than 2 kilometers (1.25 miles).

Varini has worked out a skillful way of working. He moves all over the chosen location and selects a specific 'point of view,' level with his own eyes (exactly 1.62 meters high, around 5 feet 4 inches), from which he will create his design in space. Viewers walking around the location do not perceive the complete design at once, just parts of it; they have to stand in precisely the right spot to make the image appear. Once they have found this unique point and the correct direction for viewing, they can move around as they wish to discover several successive images of the work and the location. According to Varini, all these ways of seeing are precisely what gives the work its meaning and its value.

Varini's drawings offer a way of reading the architecture on which they are created. The ten red circles he traced on a deconsecrated 16th-century chapel attempt to reveal that century's passion for geometry: seen from the 'correct' point of view, the chapel's rose window forms the eleventh circle of the design, emphasizing the harmony of the architectural composition. In this way, Varini transforms a three-dimensional space into a painting. The aim of the artist is not to create an illusion, nor to represent an imaginary landscape such as a trompe-l'oeil, but to set up a dialogue with a place, its history, and its architecture.

Felice Varini, *Ten Circles,*
1999, red chalk,
Chapelle Jeanne-d'Arc, Thouars, France

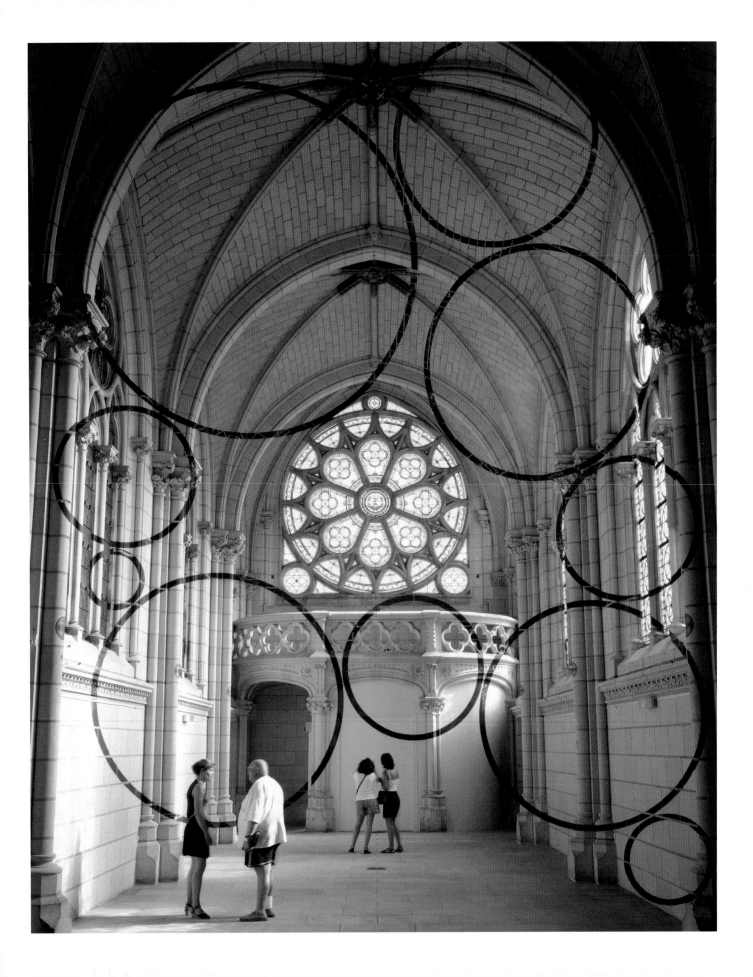

TRANSFORMED

Some works of art survive over the centuries miraculously intact, but others do not manage to reach us in their original form. Works that are installed in the open air or in public spaces are prone to the random effects of nature that sometimes, curiously, make them more beautiful. But they can also be the victims of violent events after which their survival is loaded with symbolic meaning. These spectacular transformations remain visible. By contrast, some more subtle modifications require expert analysis to reveal their secrets.

At the end of the 19th century, the great museums of the world began to set up scientific laboratories to work on the dating and care of their masterpieces. The first to do this was the Berlin State Museum, and the first experiment to analyze a painting using X-rays took place during World War I. Since then technical methods have continued to progress: infrared or ultraviolet rays, the electronic microscope, and the digital multispectral camera all enable the tracking of the slightest details in the composition and history of a work of art. The use of radiography on paintings makes visible the artist's *pentimenti*, the parts that have been painted over to cover up a figure or to change the position of an object or a part of the body. In this way radiography of Rembrandt's famous *Bathsheba at her Bath* revealed that the artist had paid

particular attention to the position of the young woman's head. At first, he had painted her head turned upwards, but subsequently he lowered the angle of her face to emphasize the expression of gentle sadness that emanates from the painting as a whole. These methods of scientific investigation give us access to the intimate processes of creativity through re-creating the steps by which a work was made. They also allow us to distinguish the real from the fake, or to detect a mark that belongs not to the artist but to a restorer. In 2010 the National Gallery in London dedicated an exhibition to paintings in which fakery or re-workings had succeeded in evading the vigilance of curators. For example, a painting from the Italian Renaissance, acquired by the museum in the 19th century, had been displayed with unnoticed re-touching until in 1978 X-rays revealed, underneath the visible figure, another *Woman at a Window*, whose appearance was markedly less puritanical than that of the first! Such alterations to suit contemporary tastes have wreaked havoc during all periods. At the start of the 19th century, when the royal courts of Europe indulged their passion for the sculpture of Antiquity, some rulers wanted to acquire originals in perfect condition. This sometimes gave rise to catastrophic results: one goddess's body would be given the head of another, and missing limbs would be attached as the talent and imagination of the restorer saw fit.

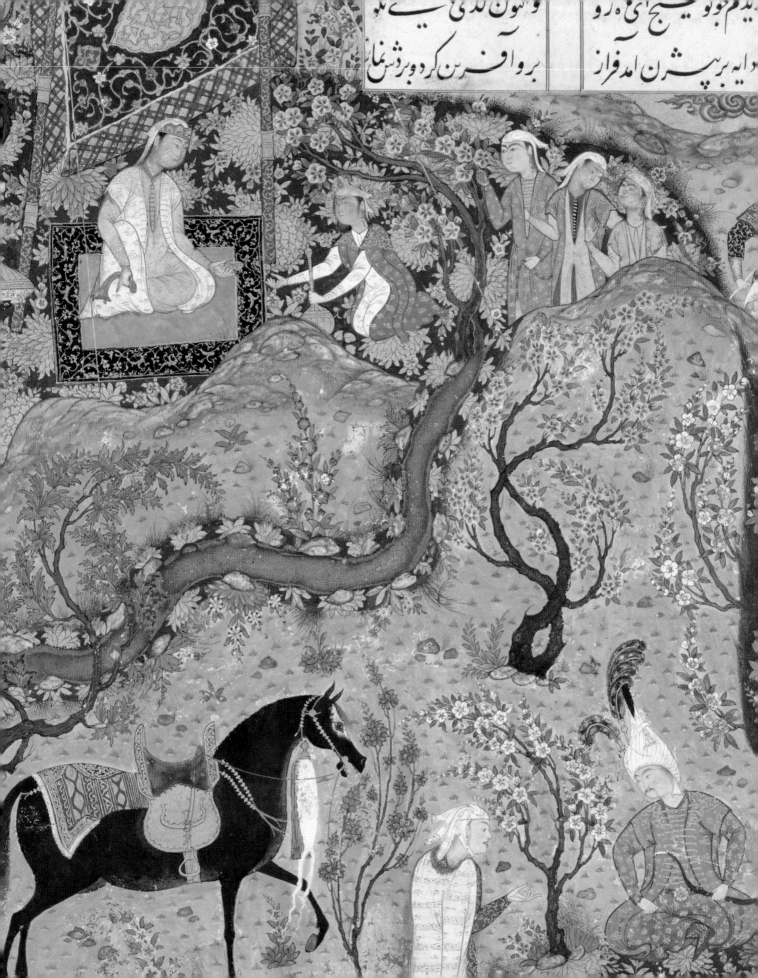

THE *SHAHNAMA* OF SHAH TAHMASP

16th century

The high winds of the art market have scattered far and wide the pages of one of the most beautiful books in the world. It's true that some great public institutions have been able to put in bids, but the most precious manuscript of a masterpiece of Persian literature will never again see its original form, except perhaps under the auspices of a temporary exhibition.

The *Shahnama*, or Persian *Book of Kings*, created for the Safavid Shah Tahmasp in the 16th century, is the most beautiful Persian manuscript known to us. Its last owner, from the 1970s until his death in 1990, sold its pages in small lots. Since then this work can be found throughout the whole world, divided between public and private collections.

The *Shahnama* of Shah Tahmasp:
Bihzan Receives an Invitation Through Manizha's Nurse
(folio 300 verso), *c.* 1520, miniature, colors, ink, 32.1 x 18.4 cm,
The Metropolitan Museum of Art, New York, USA

In 2011 at Sotheby's in London, a single page of the *Shahnama*
sold for a colossal 7.4 million pounds (12.1 million dollars),
by far the highest price ever paid for a single page of a manuscript.

The *Shahnama* is the classic masterpiece of Persian literature. Its most complete version was written around the year 1000 by Abu'l Qasim Firdausi Tusi, and it brings together ancient legends that trace the history of Persia from the creation of the world up to the Arab conquest in 651. For many years this long epic poem was the favorite source of inspiration for Persian artists. And so, during the 16th century, the political leaders ordered a written and painted version of the *Shahnama* to be made during their reign. The greatest and most luxurious *Shahnama* was created between 1520 and 1540 for Shah Tahmasp: its 759 pages and 258 miniature paintings required the work of a dozen artists, many of them the most famous of the period.

This superb manuscript remained in Istanbul during the 19th century, then was bought in 1903 by Baron Edmond de Rothschild. During World War II it was seized by the Nazis, but the Rothschild family managed to take it back as soon as the war ended. Then, in 1959, a rich New York glass magnate, Arthur Houghton, Jr., became the lucky owner for the price of two million dollars. It was thought that the *Shahnama* might be donated to Harvard University so that researchers could be assured of access to it. However, the rich collector had other things in mind. In 1971 Houghton served as chairman of the Metropolitan Museum, a fact that benefited the institution through the acquisition of 78 of the most beautiful miniatures, but no more than that. Five years later Houghton sold seven other illuminated pages through Christie's auction house and, the following year, 41 more were sent to a major London gallery. Further lots continued to be dispersed through the auction houses until, in 1994, the Museum of Modern Art in Tehran bought what was left of the *Shahnama* from the heirs of Arthur Houghton, Jr. In exchange for a painting by Willem de Kooning (estimated at more than 15 million dollars), the pages of text, 118 miniatures, and the manuscript's original binding returned to Iran.

The *Shahnama* of Shah Tahmasp:
The Feast of Sada (folio 22 verso), *c.* 1520–1522,
miniature, colors, ink, silver, and gold on paper,
47 x 32 cm, The Metropolitan Museum of Art,
New York, USA

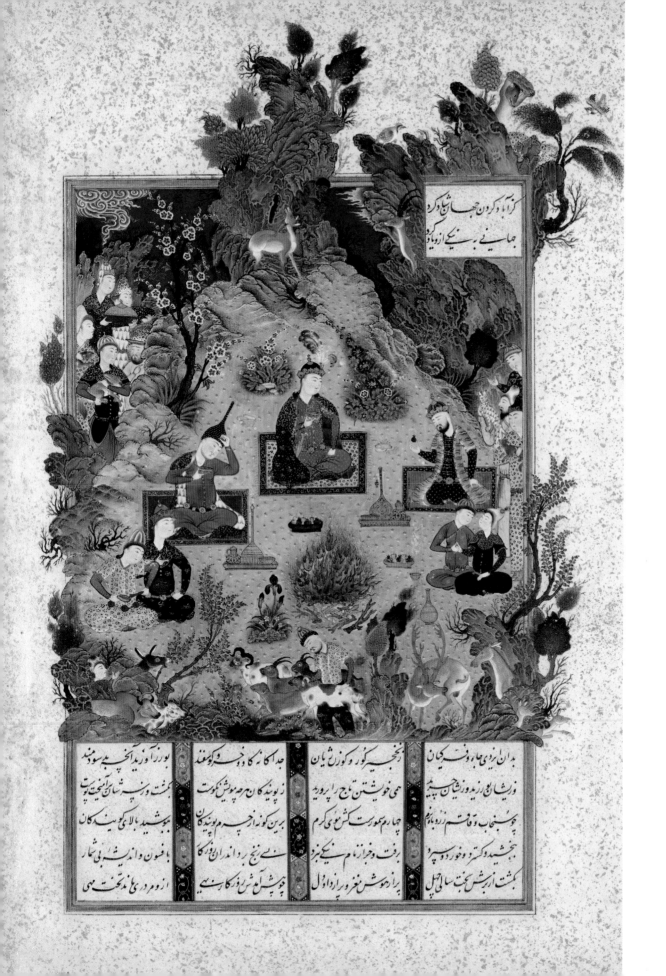

کرا آبادکردن جهان شاد کرد
جهانـى بـه نیکـى ازو یادکرد

بدان برزى جاه و فرّ کیان
پنجخـه کـور و کوزش ثیان
جدا کاه کـادخـرکـومـنـد
بورزاورآیدازآنکه بسود منـد

وریشان بـبرزیـدوزیشان پـیـم
مى خویشتن تاج را پرورید
زپویدگان کان هرصه پوشش کورت
کشت ورپنه شان آنکین کبوت

چوسنجاب و قاقـم ازرورپاپم
چهارم صورت کش مى کـى کرم
بربن کـورت ازجـم مونـد کیـان
بوکشید بالاى بـنه که کان

بنجخید وکرکد ونورسپرد
سنیى بنج بردانـدران زرکرد
یافنون واندیشـرى بـى شمار
ازومردى برنه تخت می

کشت ازبرش سخت سالى اجل
پراهوش بغرویرازدو دل
چوپشل ثن زورکاسبیى
ازومردى برنه تخت می

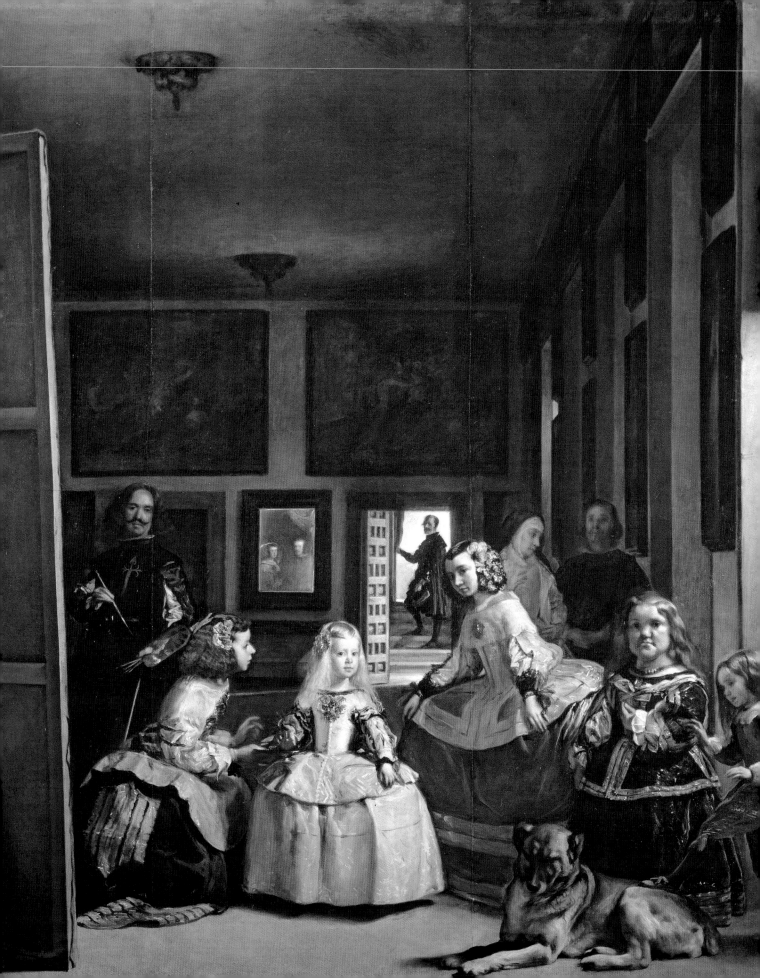

DIEGO VELÁZQUEZ
LAS MENINAS

1599–1660

"Everything about this painting has been interpreted, even what we cannot see," wrote art historian Daniel Arasse in 2000. The rich complexity of Velázquez's *Las Meninas* had already given rise to multiple interpretations when an unexpected discovery launched a frenzy among the critics—there was another painting hidden underneath.

Las Meninas, as we can see it today at the Prado Museum in Madrid, Spain, is covering up another version of the painting. When the canvas was X-rayed, a procedure used to enable old paintings to be restored faithfully, the presence of major modifications, made by Velázquez himself, was revealed.

Diego Velázquez, *Las Meninas* (*The Family*), 1656,
oil on canvas, 318 x 276 cm,
Prado Museum, Madrid, Spain

Las Meninas is a masterpiece of inexhaustible interest not only to critics
and art historians, but also to artists as well.
At the end of 1957, Pablo Picasso painted 58 different versions of it.

In 1656 King Philip IV of Spain commissioned a painting from Diego Velázquez, his court painter since 1623. The scene depicted takes place in a room in the royal palace of Madrid that Velázquez used as his studio. Before being titled *Las Meninas* in a Prado catalogue of 1843, the work was called *The Family*, and the royal family is indeed there in its entirety, including members of the royal household. In the middle there is the Infanta Margarita and her ladies-in-waiting (the *meninas*), surrounded by other courtiers, while the king and queen are present by means of the famous reflection in the mirror. The work can be interpreted as a private portrait, originally destined for a lone viewer, the man who commissioned it. The entire painting is constructed from his perspective, from his privileged view of the scene. Moreover, it was hung in the king's summer apartments until 1736. The originality of Velázquez's idea is striking: he imagines he is in the middle of painting the royal couple when their daughter comes into the studio, and then depicts this purely imaginary moment. Such originality and intimacy also indicates that this was a private painting and not an official portrait.

So what do the X-rays reveal? Many of the retouchings, above all in the area where Velázquez himself appears, correspond to his reworking of the canvas in 1659. We know that at that time Velázquez added to his doublet the red cross of the Order of Santiago that the king bestowed on him two years after the painting was made. But it is also highly probable that Velázquez also added his own portrait at that time.

In Velázquez's place there seems to have been a young woman, who could well have been the king's eldest daughter, Infanta Maria Teresa. This first version would thus have been a dynastic painting, for public consumption, and not a private fantasy, for it communicated an important piece of information: King Philip IV had chosen to marry Maria Teresa to Louis XIV of France, and to make Infanta Margarita the heir to the Spanish throne. But in 1657, a son and heir was born, and this obliged Velázquez to change his painting, which had thereby lost its meaning.

By inserting himself into the scene, Velázquez also transformed his work into a homage to painting, as it represents representation itself. This is why *Las Meninas* has become a masterpiece famous for giving rise to multiple and sometimes contradictory interpretations.

X-ray photograph of *Las Meninas*,
Prado Museum, Madrid, Spain

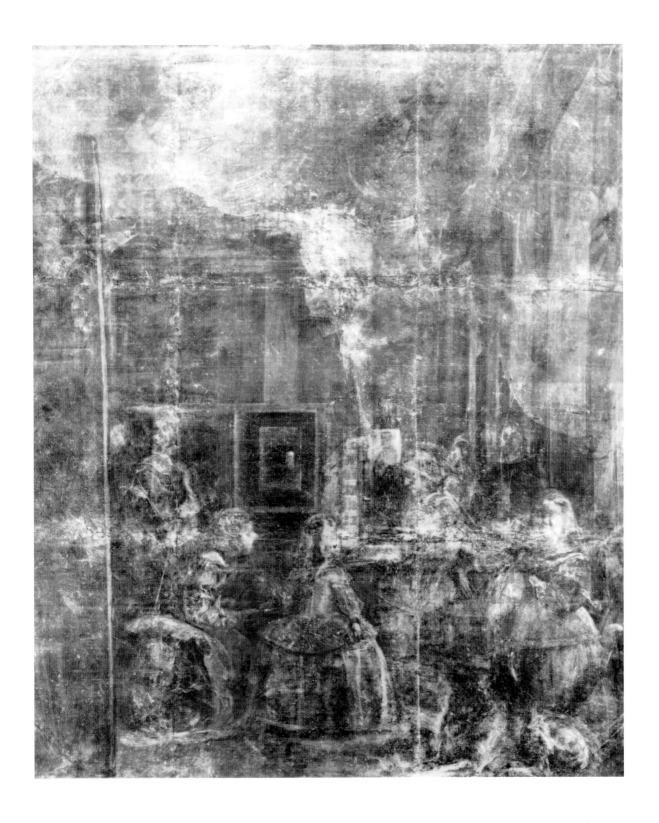

THE REGENT DIAMOND

Found 1698

From the mines of Golkonda in India to the French crown jewels, the impressive diamond that Napoleon I carried as decoration on his sword went through more wanderings than its transient owner. Indeed, this precious stone has adorned an astonishing number of crowned heads.

In 1698 at Golkonda in India a stone of extraordinary size was extracted from the diamond mines. Acquired by Thomas Pitt, governor of Madras, this 426-carat diamond was sent to an English jeweler in 1702, where it underwent its first transformation. After secondary stones were cut from it and sold to Tsar Peter the Great, the main stone—because of its purity, and because its color made it of the 'first water'—was still the most beautiful diamond known in the West up to that time.

Robert Lefèvre, *Portrait of the Emperor Napoleon I Wearing the Uniform of the Grenadiers de la Garde à pied* [with the Regent Diamond in his sword], 1806, oil on canvas, 216 x 156 cm, Petit Trianon, Palace of Versailles, France

A fabulous diamond of Indian origin travels to England to be cut. For two years a jeweler named Harris worked on it using a technique that allowed him to create perfect facets and angles with an astonishing sparkle. In 1717, bolstered by the prevailing economic prosperity in France, Philip of Orléans asked the Council of Regency to buy the jewel. From that moment on the diamond took the name of its owner, the 'Regent,' and joined the collection of the French crown jewels. The Regent Diamond then embarked upon a career that resembled a game of hide-and-seek. Set in the coronation crown of Louis XV on October 25, 1722, it then appeared worn in his hat. For Louis XVI's coronation on June 11, 1775, the Regent Diamond adorned a new crown. Louis XVI would himself also wear the diamond in his hat, and Marie-Antoinette was fond of borrowing it from him. In 1792 the Regent fell victim to theft but reappeared the following year, hidden in some roof timbers. Pledged as security on several occasions by the Directoire and the Consulate after the French Revolution, the diamond was redeemed by Napoleon I in 1812. It is said that Empress Marie-Antoinette took it with her when she went into exile, though she finally returned the irrepressible stone to France. The Regent Diamond continued to follow changes in regime, appearing in the crowns of Louis XVIII, Charles X, and Napoleon III, then in the diadem of Empress Eugénie. In 1887 the Regent Diamond was one of the historic treasures to escape the auctioning of the crown diamonds. It was entrusted to the Louvre Museum in Paris, which has looked after it ever since.

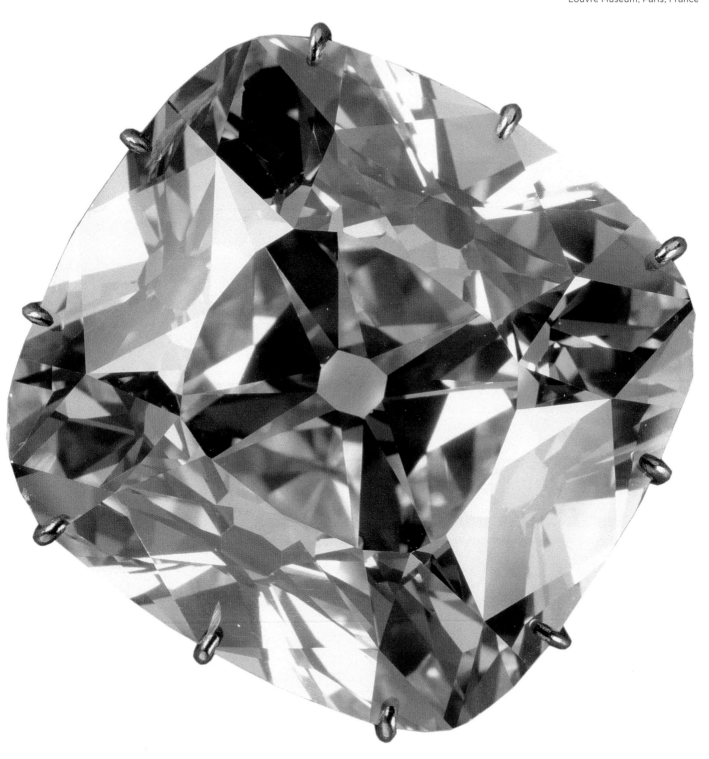

The Regent Diamond, *c.* 1702,
Crown Jewels Collection,
Louvre Museum, Paris, France

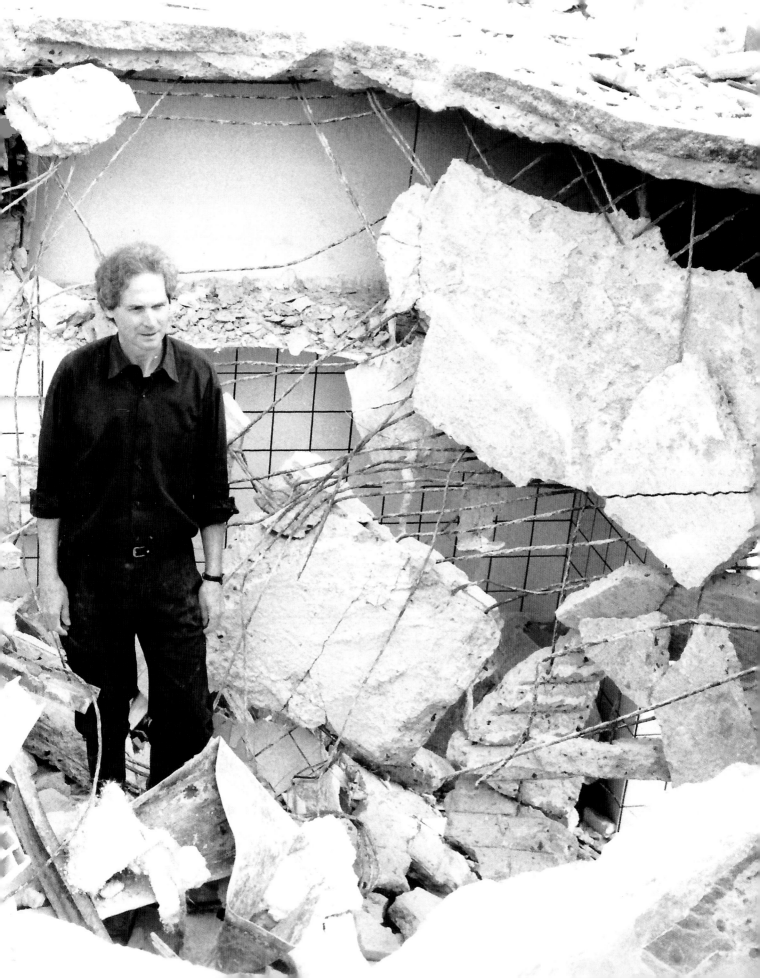

JEAN-PIERRE RAYNAUD
LA MAISON

1939–

Destruction is not always synonymous with disappearance. An artist can destroy an artwork by transforming it. This process is all the more disturbing when the monumental work is the artist's own home.

In 1969 Jean-Pierre Raynaud began work on a house using his favorite material, white ceramic tiles. For 23 years he dedicated himself to this work, getting involved to the extent of making it into his home. In 1993 he decided to destroy it and exhibit the pieces of *La Maison* in a museum. The house has certainly disappeared, but another artwork was born from its ruins, and bears the same name.

Jean-Pierre Raynaud during the demolition of *La Maison* in 1993

"The aim is not to make works of art, but
to live the work or art as an aim in itself."

From the start, *La Maison* constituted a process of transformation—the metamorphosis of a modest villa in the Paris suburbs into a work of art. Over the course of 23 years of 'artistic building work,' Jean-Pierre Raynaud continued the evolution of his artwork-cum-home. Having completely 'dressed' the interior with white ceramic tiles, he fitted out the doors and windows on the outside. By 1974 *La Maison* was open to visitors: for many, this strange abode lined with white tiles must have looked like a hospital or morgue, conjuring up morbid images; or, on the other hand, feelings of purity and the absolute. For Raynaud, it was an intimate place, like a body. The very special relationship he had with this work of art led him to invent a second life for it. He said in 1993: "I realized that as this house was unique it was worth more daring

and consideration than the perfect, fixed architecture it had become—which is the domain of art objects. I had to find an exceptional fate for the house, one worthy of it. I decided to transform it, to take is elsewhere, to allow it to live through an absolute experience. To do this it had to undergo the ultimate transformation—demolition." Thus it was that with the assistance of Bordeaux's contemporary art museum, the house was destroyed and its rubble, filling a thousand small containers, was transported to the museum to go on display and form a new work of art. The metal trash cans that contain the ruins of the work are like those used in operating theaters, thus making the debris of the house seem like human remains, and helping to preserve the memory of *La Maison*.

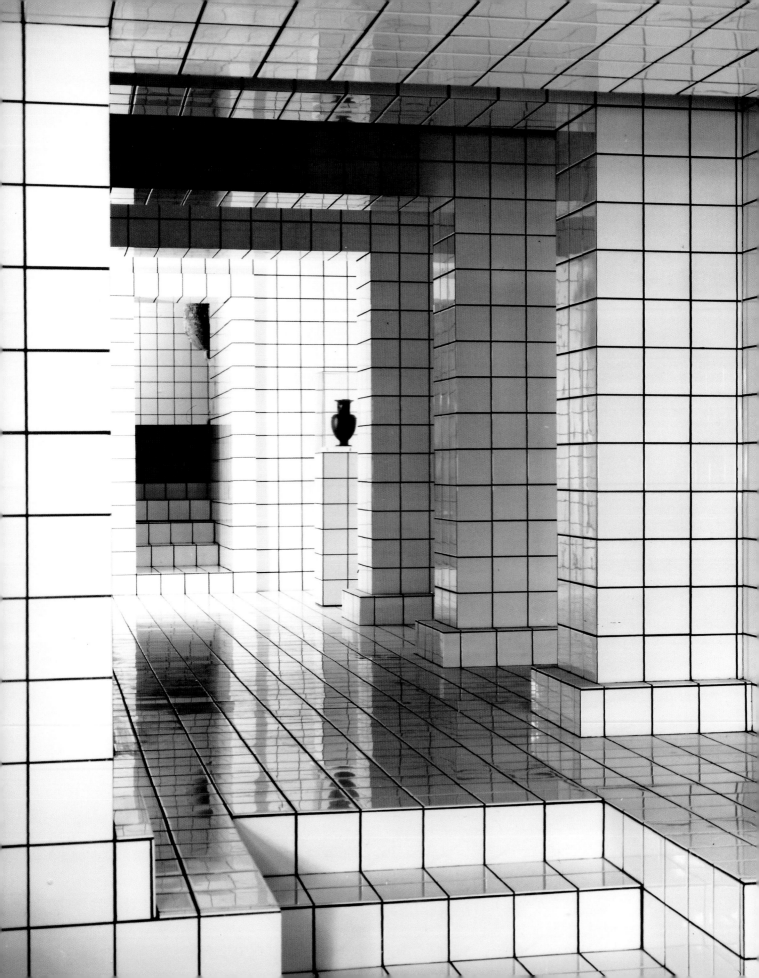

ROBERT SMITHSON
SPIRAL JETTY

1938–1973

Through the magic of the elements that form it and that surround it, a monumental work of art has been playing a game of hide-and-seek with its visitors for more than 40 years.

When he created *Spiral Jetty* in 1970, did Robert Smithson imagine the extraordinary fate that awaited his work? Two years after its installation it was submerged by the rising waters of the Great Salt Lake in Utah. At that time, visitors had to view the work from the air to glimpse it through the transparent surface waters of the lake. But in 1973 there was a dramatic change: as the water level dropped, the spiral emerged covered in large salt crystals, giving it an even more spectacular appearance, an effect that lasted for just four months.

Robert Smithson during the construction of *Spiral Jetty*.
Photo: Gianfranco Gorgoni

"As I looked at the site, it reverberated out to the horizons only to suggest

an immobile cyclone while flickering light made the entire landscape appear a quake.

A dormant earthquake spread into the fluttering stillness, into a spinning sensation

without movement. This site was a rotary that enclosed itself in an immense

roundness. From that gyrating space emerged the possibility of the *Spiral Jetty*."

Robert Smithson, 1972.

For the construction of *Spiral Jetty*, Robert Smithson rented four hectares (nearly ten acres) of the Great Salt Lake near Rozel Point, Utah, a region of desert in the west of the USA. The lake's red color, caused by the algae that inhabit it, gave Smithson a natural canvas on which to design a spiral 460 meters (1,500 feet) long. The artist mobilized hundreds of technicians, tractor-trailers, and mechanical diggers to move the earth and black basalt rocks that make up the huge serpentine form. Paradoxically, the scale of these major mechanical works plays on the impression that the work originated within the Earth itself. Its appearances and disappearances reinforce this magical character: it vanished in 1972 only to resurface enhanced the following year for a temporary period. But since 2003 it has emerged once again, saved from submersion by the droughts that plague the region. *Spiral Jetty* exists through its archives.

However, the idea for this artwork did not come solely from the natural grandeur of the site. It also refers to ancient mythological tales. The existence of a landlocked salt lake had already aroused the curiosity of the first inhabitants of this region, and gave rise to many unscientific explanations. According to one of the legends, the lake was linked to the Pacific Ocean by a huge underground current that formed deadly whirlpools at its center. It was the image of this vortex that inspired the shape of Robert Smithson's spiral. The sense of vertigo that the visitor might feel when faced with *Spiral Jetty* perhaps also derives from the ancient fears that the work revives. Doubtless this mythological dimension, which the artist has incorporated into the very form of his creation, contributes to making *Spiral Jetty* an iconic masterpiece of Land Art.

Robert Smithson, *Spiral Jetty*, April 1970,
black basalt, salt crystals, earth, algae, 4.6 x 460 m,
Great Salt Lake, Utah, USA

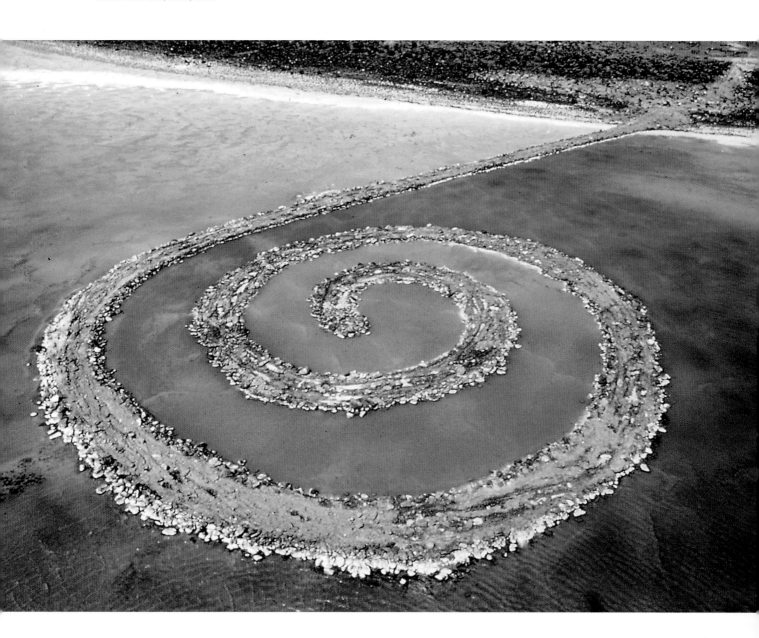

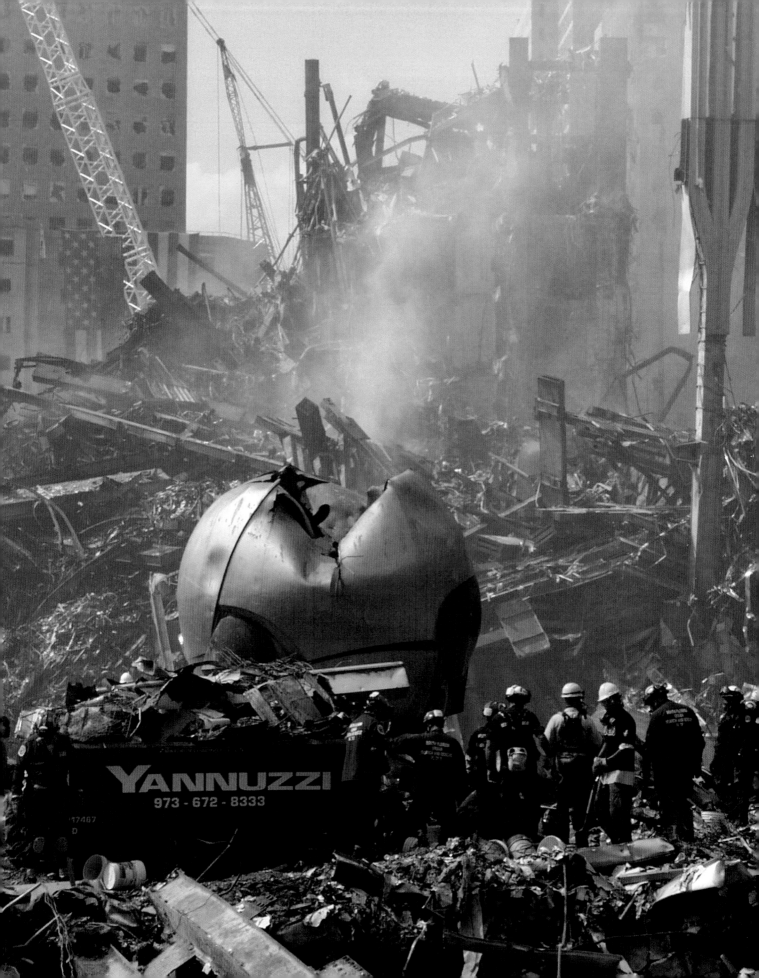

FRITZ KOENIG
THE SPHERE

1924–

Works of art can of course pursue a destiny that is quite separate from that of their owners. But when a sculpture survives an extraordinarily murderous attack, it acquires a symbolic force beyond measure.

After the attacks of September 11, 2001, in New York, *The Sphere*, a monumental sculpture by the German artist Fritz Koenig, which was located in the middle of a plaza at the World Trade Center, was damaged but still survived beneath the rubble. This spirit of resistance deemed it worthy of conservation and it was re-located as a memorial to the victims of 9/11 in a park in Lower Manhattan.

The Sphere by Fritz Koenig after the attacks of September 11, 2001

Fritz Koenig, *The Sphere*, 1971,
bronze and steel, damaged during the
September 11, 2001, attack,
Austin J. Tobin Plaza, then Battery Park,
New York, USA

When Ground Zero is rebuilt, Fritz Koenig's *Sphere* will be returned
to its original setting, but from now on invested with
the memory of the September 11 attacks.

Fritz Koenig worked on his *Great Spherical Caryatid*, his response to a commission from New York's Port Authority, from 1967 to 1971. Overlooking a fountain on Austin J. Tobin Plaza, the sculpture was quickly adopted by New Yorkers, who nicknamed it 'The Sphere.' The piece rotated every 24 hours, symbolizing peace on the planet beyond international commercial trading. Koenig had seen the meaning of his work in relation to the installation site, one of the most sensitive locations for world trade and therefore stability, which became the target of atrocious carnage 30 years later. The sculpture, made from 20 metric tons of bronze and steel, was found beneath the rubble and still today bears the scars of the attack. Its 'survival' has invested it with a new symbolic responsibility: re-located to Battery Park, today it stands as a temporary memorial to the victims of September 11.

In 1983 Fritz Koenig created the monument for the Federal Republic of Germany in the former concentration camp at Mauthausen in Austria, and, in 1995, a homage to the victims of the Munich massacre during the 1972 Olympic Games. In retrospect, these works by Koenig make the strange destiny of *The Sphere* even more poignant and disturbing. His original homage to peace was transformed, beyond any artistic intention or intervention, into a memorial. The work thus acquired a second life, invested with the same symbolism of peace, but in another form, independent of the artist, and fashioned by a cynical gesture of terrorist violence.

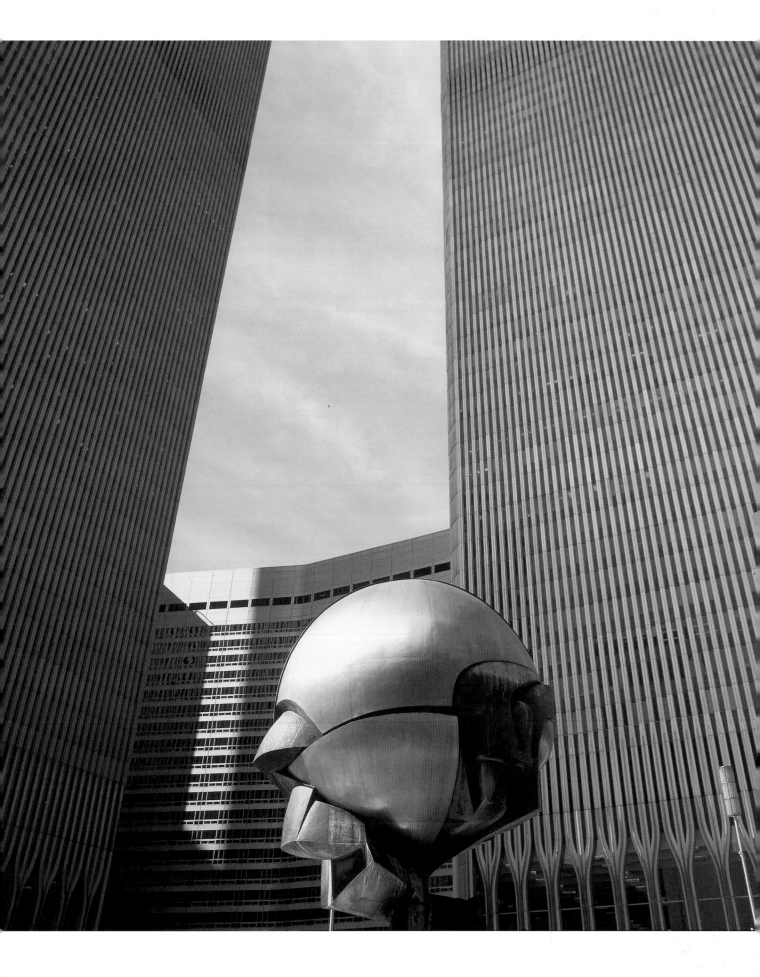

DESTROYED

Without question wars are the most formidable enemies of the work of art. In 1936, at the beginning of the Spanish Civil War, the Madrid government started to protect monuments such as the Fountain of Cybele by encasing them in brick sarcophaguses. A similar method was used decades later by the curator of the National Museum of Beirut, who put sandbags around the larger sculptures that could not be moved out of harm's way, and spread a layer of protective concrete over mosaics. At the beginning of the uprising in Madrid, Spain's artistic heritage was threatened by aerial attacks from the Nationalists. The town of Guernica was bombed in 1937, a tragic episode universally known thanks to Picasso's masterpiece. By contrast the collections of the Prado Museum, after much vacillation, were finally taken by train to the Palace of the League of Nations in Geneva at the beginning of 1939. An agreement stipulated that of course the works would be returned to Spain as soon as peace was restored; and, indeed, the thousands of works of art saved in this way were returned several months later. During World War II several countries followed this example. As early as 1938, the curators of the Louvre in Paris were planning how to safeguard their collections. For several months the Louvre was transformed into a vast packing depot, before the works were sent to several locations in Touraine, notably to the Château de Chambord. After the German invasion, the works were once

again removed, this time to the center of France. Despite these precautions, hundreds of paintings by Fernand Léger, Joan Miró, Francis Picabia, Pablo Picasso, Suzanne Valadon and others were burned by the Nazis on May 27, 1943, on the terrace of the Tuileries in Paris.

In London during World War II, the National Gallery collections were put into storage in the corridors of the Strand subway station. A few months later it was necessary to find other shelters. Thus the galleries of a slate quarry were made suitable to house the works safely. This was a fortunate initiative, as the National Gallery was bombed five times in 1940 and 1941. In Russia, German troops machine-gunned the cathedrals and museums and let cattle wander through the palaces, while in Germany works of art vanished as soon as the Russians were victorious. Whatever the war, whoever the combatants, works of art are the frequent victims of conflicts.

Some works of art can also be the objects of personal wars. In 1975, Rembrandt van Rijn's *The Night Watch* was attacked by a man armed with a knife. Ten years later, another iconoclast sprayed the painting with acid. Now restored, Rembrandt's masterpiece lives to see another day on the walls of the Rijksmuseum in Amsterdam.

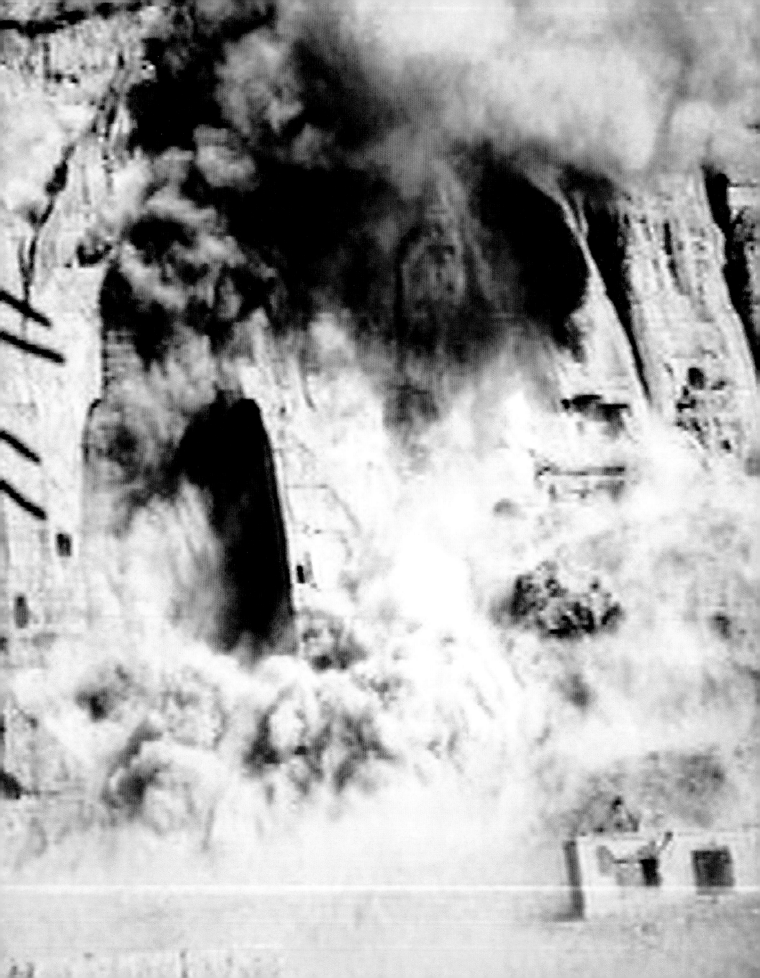

THE BUDDHAS OF BAMIYAN

c. 600–700

Wars do not just destroy human life; they can also attempt to eradicate the values that underpin human cultures. Thus works of art can be considered enemies, and statues blown up with high explosives.

Two large statues of the Buddha had dominated the superb Bamiyan Valley for almost 1,500 years when they were attacked by the Taliban in March 2001. These stone giants, which had successfully resisted the Mongols and the pillaging and wars that have ravaged Afghanistan, even in the 20th century, had become too much of a provocation for the ruling regime.

The destruction of two Buddhas of Bamiyan
by the Taliban, March 12, 2001

In 2008 a team of international researchers were collecting fragments of the frescoes that adorned the niches where the Buddhas stand, and in doing so they discovered another treasure hidden inside. Analysis has revealed that oil paint might have been used in this location for the first time, 600 years before the Renaissance, the period to which the invention of this technique in Europe is attributed. Thus these frescoes might be the oldest known oil paintings in the world.

Located on the Silk Route that links China and India to the West, Bamiyan was one of the most important centers of Buddhism in Afghanistan. Since the 2nd century AD, the small cells cut into the cliff-face the entire length of the valley have housed about a thousand monks. These grotto sanctuaries also contained pre-Islamic treasures of Buddhist art, such as the two giant Buddhas that were cut into the rock of the mountainside. Stylistically, the sculptures were examples of the meeting between Buddhist art and influences from the Greece of Alexander the Great. The smaller Buddha, 38 meters (125 feet) tall, had wavy hair in the Greek style, and a monk's pleated robes; the larger Buddha, also wearing red, blue, and gold, had flames coming out of his stucco-coated shoulders, and stood 55 meters (180 feet) high.

The face of the larger Buddha was probably destroyed when Islam first arrived in the region in the 9th century, as traditional Islam forbids the depiction of the human face. In the 13th century, Genghis Khan put an end to Bamiyan's prosperity by destroying the town. The first archeological digs started around 1920; pillagers were alerted by the richness of the site, which later continued to be damaged by over 20 years of war. Then came the end: on February 26, 2001, the Taliban leader Mullah Omar decreed the destruction of all Buddhist statuary, as he considered it to be 'anti-Islamic.' After several weeks of intensive bombing, and despite international pressure to prevent the demolition of the statues, the two Buddhas were no more. In 2003 UNESCO added Bamiyan to the list of world heritage sites in danger.

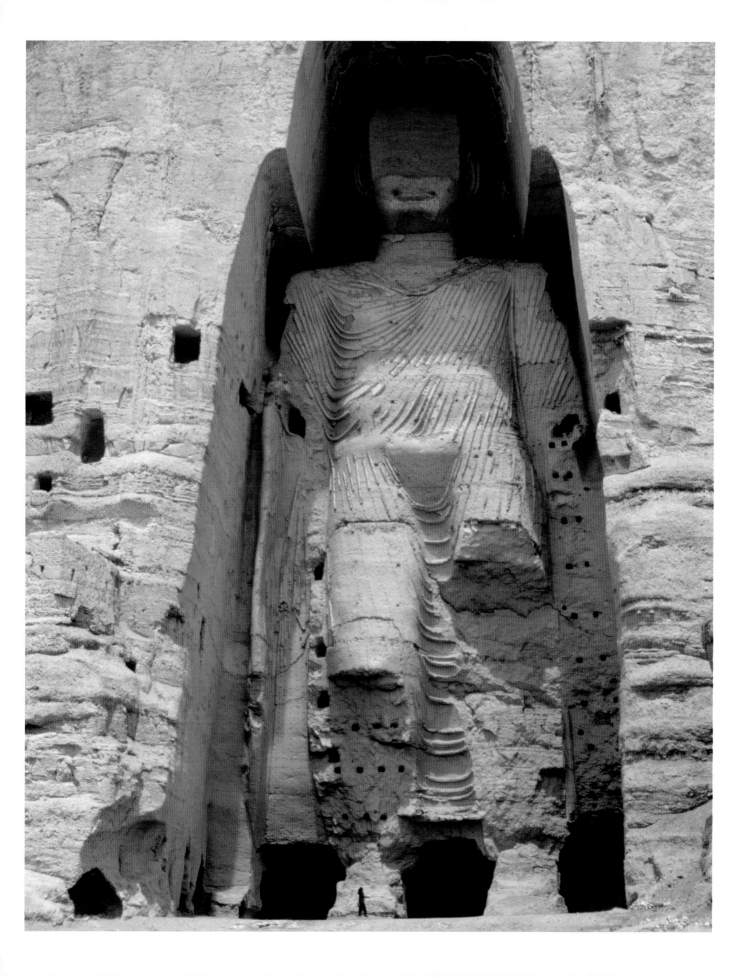

NIKLAUS MANUEL DEUTSCH
THE BERN *DANCE OF DEATH*

1484–1530

During the 15th and 16th centuries, and mainly in northern Europe, the Dance of Death was a favorite theme for frescoes in churches and cemeteries. Commissioned works intended for the edification of the peasantry, these murals have themselves succumbed to the inevitable depredations of time and chance.

From 1516 onwards, Niklaus Manuel Deutsch's *Dance of Death*, which decorated the walls of a cemetery in Bern, Switzerland, was the most famous monument in the city. The series of 46 scenes extended over more than 100 meters (328 feet). Unfortunately, the work was destroyed in 1660 as a result of urban re-developments. However, a copy appears in a manuscript of paintings and writings made in 1649 by a local artist, Albrecht Kauw.

Albrecht Kauw after Niklaus Manuel Deutsch (*c.* 1515–1516), the Bern *Dance of Death*: *Death and the Artist*, 1649, watercolor, Historisches Museum Bern, Switzerland

The *Dance of Death* fresco, because of its monumental size and conspicuous location, created an excellent advertisement for its 16th-century painter, who was at the time considered a mere craftsman.

The power of the Bern *Dance of Death* lies without doubt in Niklaus Manuel's ability to produce a witty, contemporary interpretation of an overworked theme. In 1516 Manuel returned from fighting in Italy expecting to take up once again his privileged position in his native town. In painting the scenes he complied with the imperatives of traditional iconography in this kind of painting, but took advantage of the public commission to portray all the leading figures of Bern, depicted life size and in fashionable dress. Moreover, he completed the fresco by adding a self-portrait: even the painter is interrupted in his work by Death. This was a skillful way of inserting himself into Bern's high society. But just as the monumental fresco was finished, the Church underwent a profound crisis. The followers of the Reformation accused the clergy of profiting scandalously at the expense of their congregations, not least through the practice of selling 'letters of indulgence' that promised to buy the sins of those who spent the most money. Siding with the Lutherans, Manuel mocked the Church in the same terms used by his fellow citizens, employing little extracts of dialogue to caption his paintings. All Manuel's models seem to take part in the mortal game, dressed up as bishops, cardinals, and the pope, and submitting to the mockery of Death, who ferociously denounced their fat stomachs! The scenes of the Dance of Death, traditionally intended as a meditation on the theme of mortality, are adapted here for a contemporary context. Much more than mocking the vanity of social distinctions in the face of death, Manuel lends a polemical and also carnivalesque touch to his fresco. This brought him well-deserved success, and as a result he rapidly became rich thanks to numerous commissions, finally abandoning his status as a craftsman and taking on important municipal positions.

Albrecht Kauw after Niklaus Manuel Deutsch (*c.* 1515–1516),
the Bern *Dance of Death*: *Death and the Pope*, 1649, watercolor,
Historisches Museum Bern, Switzerland

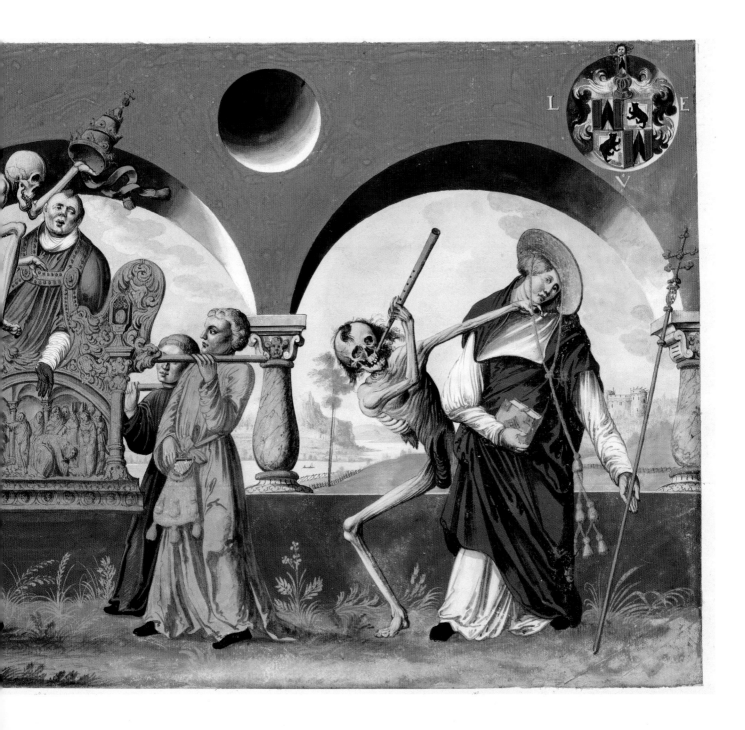

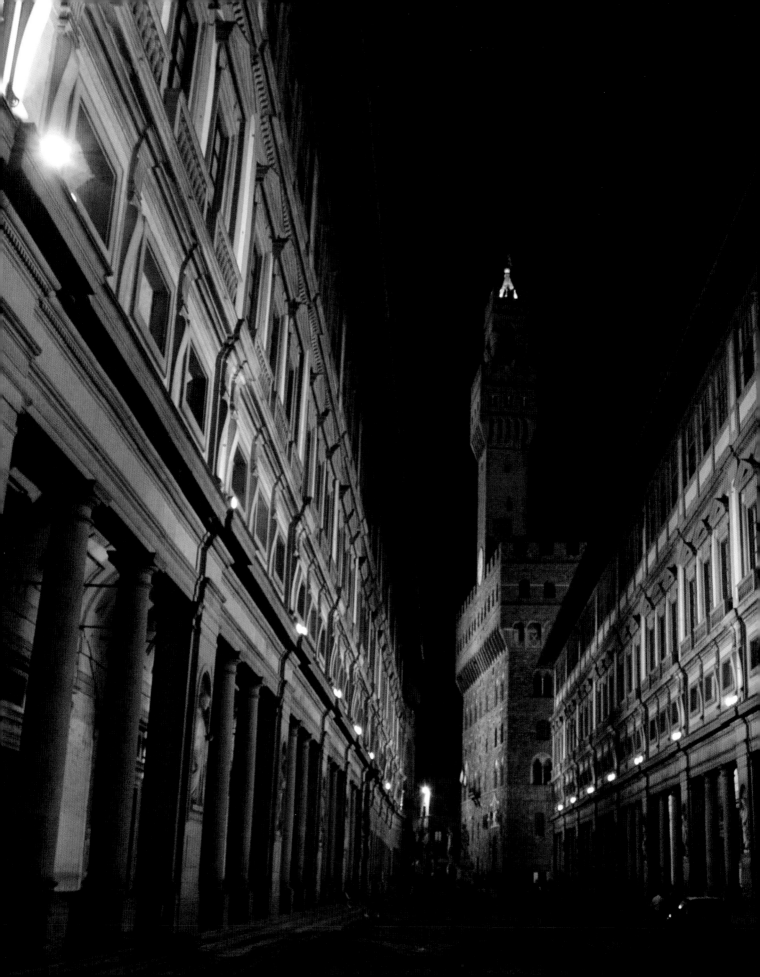

GERRIT VAN HONTHORST
THE ADORATION OF THE SHEPHERDS

1590–1656

On May 27, 1993, a bomb exploded near the Uffizi Gallery in Florence. Several people were killed in this Mafia-organized attack, whose prime target was the museum itself.

The famous Uffizi Gallery houses several paintings depicting the Adoration of the Shepherds by celebrated artists such as Hugo van der Goes and Lorenzo di Credi. And among the many versions there was one by the Dutch artist Gerrit van Honthorst, who lived in Florence during the 17th century. But in 1993 the painting by this northern follower of Caravaggio was destroyed by a bomb attack.

View of the Palazzo Vecchio and the Uffizi Gallery, 2006, Florence, Italy

Because of the very dark colors of his palette, Gerrit van Honthorst was nicknamed by the Italians Gherardo delle Notti—'Gerard of the Night.'

In the spring of 1993, bomb attacks continued their deadly course aimed at the Uffizi Gallery in Florence, the Museum of Contemporary Art in Milan, then the basilicas of San Giorgio in Velabro and St. John Lateran in Rome. Attributed to the Mafia, these lethal assaults on the artistic heritage of Italy were really aimed at international tourism, the successful economy of the Milanese middle-classes, and the Pope.

On the night of May 27, a booby-trapped car exploded in the very heart of Florence, ripping apart one of the towers on the Piazza Signoria and damaging one of the neighboring buildings, the Uffizi Gallery. The attack killed five people and injured around 30. In the Uffizi, apart from the famous staircase designed by Buontalenti, which was seriously damaged, around 200 works of art had to be restored. Just three paintings were irreparably destroyed—three works among the more than 4,000 in the collection. A major national and international mobilization meant that the museum reopened less than a month later.

The Uffizi Gallery is one of the oldest museums in the world: it has been open to the public since 1765 and today houses a great number of world-renowned masterpieces. Tourists crowd there every day in their thousands to admire the works by the Italian painters of the Renaissance. In 1610, attracted by the reputation of these painters, the young Gerrit van Honthorst went to Italy to complete his training. *The Adoration of the Shepherds,* which he painted during this stay of about ten years, is one of the three paintings of the school of Caravaggio that were destroyed by the explosion. Beyond his mastery of the technique of *chiaroscuro* (contrasts of light and dark), Honthorst took from Caravaggio's compositions the realistic depiction of ordinary people viewed at half-length. On his return to the Netherlands, Honthorst set a precedent with his Caravaggesque style and enjoyed exceptional success in the courts of Europe.

Gerrit van Honthorst,
The Adoration of the Shepherds,
1620, destroyed 1993, Uffizi
Gallery, Florence, Italy

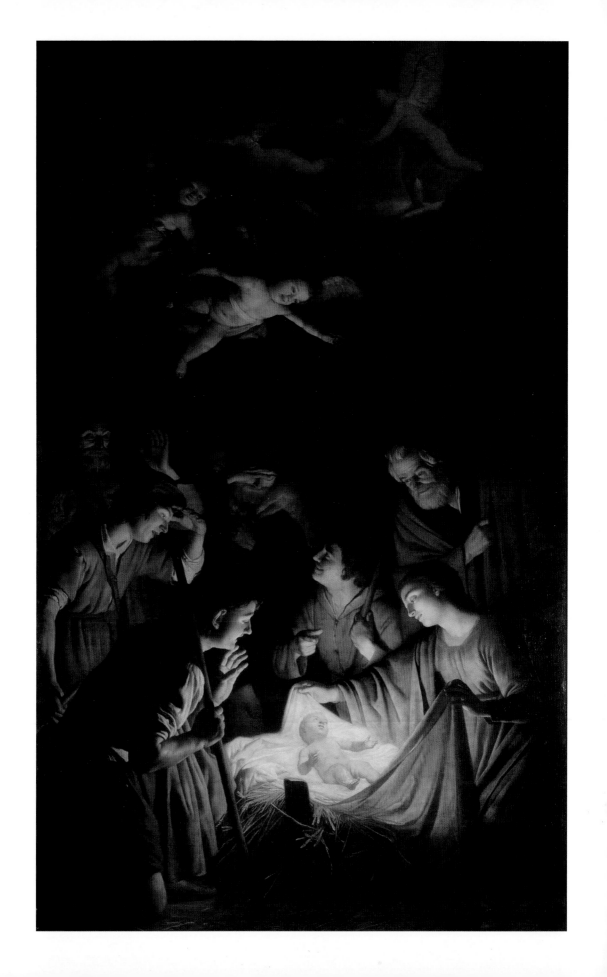

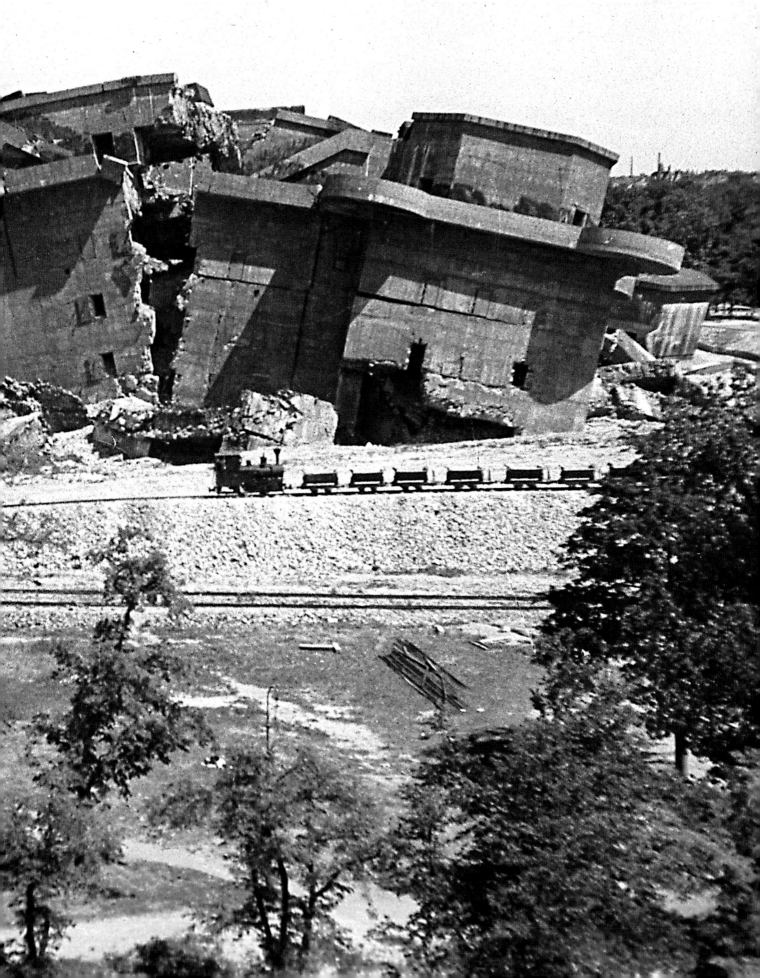

PETER PAUL RUBENS
THE BACCHANAL

1577–1640

During World War II, Germany, like many other European countries, evacuated its works of art from museums to more secure shelters; in Berlin, one such location was the bunker at Friedrichshain in Berlin.

From 1937 onwards, the Nazis removed certain works from German museums in order to sell or destroy them under the pretext that they were ›degenerate art'; other works were later moved to protect them from enemy bombing. In Berlin, anti-aircraft towers, the *Flacktürme*, had been built, and they housed, among other things, works of art. But in May 1945, when the city was in Allied hands, more than 400 paintings were destroyed during a fire in the *Flackturm* at Friedrichshain in circumstances that have remained mysterious.

The bunker at Friedrichschain in Berlin, where hundreds of works of art were sheltered

Apart from this *Bacchanal*, at least three other works by Peter Paul Rubens
went up in smoke in the Friedrichshain bunker in Berlin in May 1945.

The Kaiser Friedrich Museum in Berlin was bombed sev-
eral times and, despite the evacuation of its collections,
it lost a large part of its holdings. Four hundred and sev-
enteen paintings from the museum had been sheltered
in the Friedrichshain bunker. A complete catalogue could
not take account of the extent of the catastrophe that
befell this one public collection alone: works from the
Italian Renaissance and the Dutch Golden Age, by Car-
avaggio, Canaletto, Rubens, Cranach, Zurbarán, Goya,
and Caspar David Friedrich, among many others. Ironi-
cally, the artistic heritage of all the countries at war was
affected.

By contrast, the works of art that were protected in the
Flakturm am Zoo, an identical anti-aircraft defense, had
a different fate, for this fortress remained standing
despite the bombing. But in March 1945, in the face of the
Red Army's advance, Hitler ordered that part of the col-
lections housed there should be moved to mines located
west of the River Elbe. American troops found the works
shortly afterwards. Other treasures were taken to Russia,
to return much later. It was only in 1992 that Russia and
Germany signed a treaty of cultural cooperation by which
they mutually agreed to return the works of art that had
been illegally plundered.

Peter Paul Rubens, *The Bacchanal*,
17th century, oil on canvas,
212 x 260 cm, disappeared May 1945
from the Gemäldegalerie, Berlin,
Germany

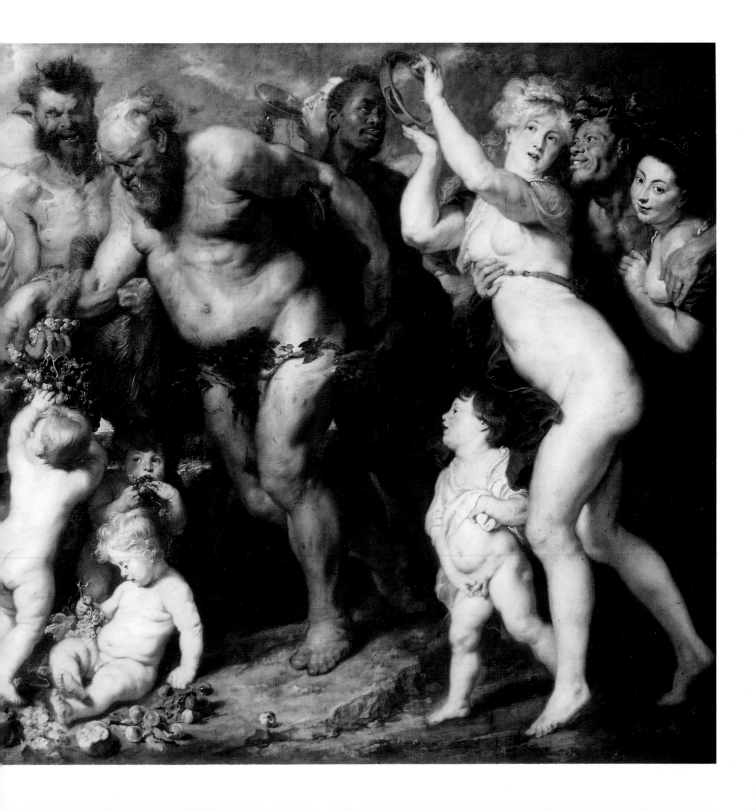

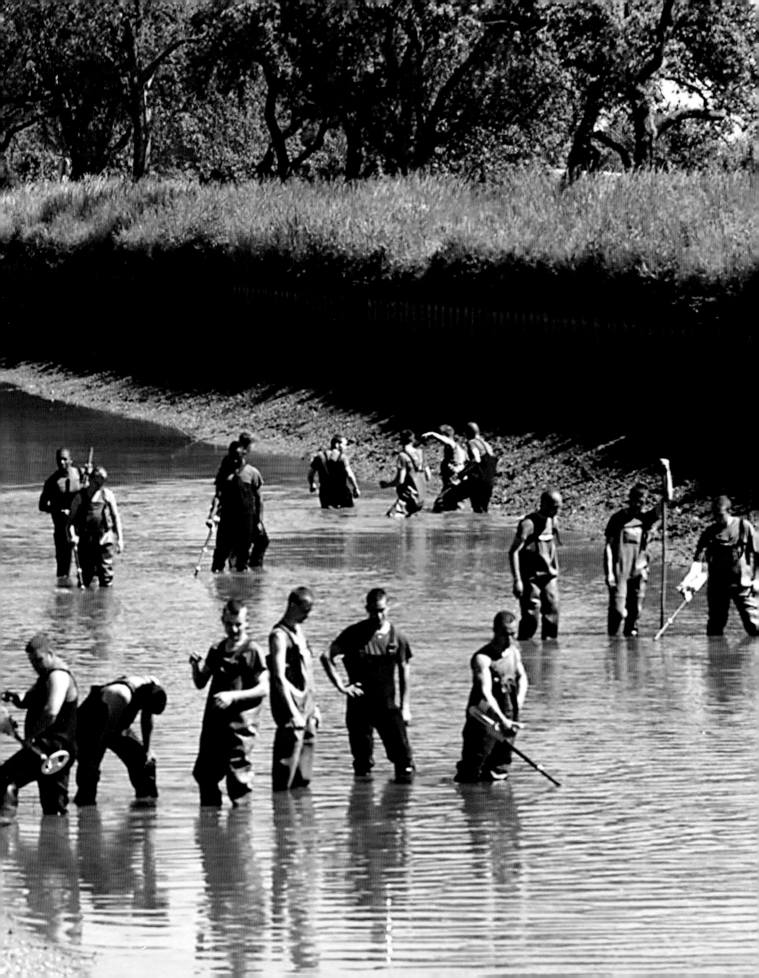

FRANÇOIS BOUCHER
THE SLEEPING SHEPHERD

1703–1770

An army can sometimes find itself taking part in peaceful missions, such as this treasure hunt at the bottom of a canal that led to the discovery of around one hundred art objects. Art can sometimes provoke dark obsessions.

On May 16, 2002, a strange scene unfolded on the Rhine-Rhône Canal near Gerstheim in France. Soldiers were dragging the canal in search of art. An incredible haul, accumulated by a fanatical kleptomaniac, made up of works of art stolen from various European museums, had been thrown into the canal by the mother of the alleged perpetrator.

Soldiers dragging the Rhine-Rhône Canal at Gerstheim, France, May 16, 2002

The Sleeping Shepherd did not survive the angry—guilty or terrified—
 blows inflicted by the mother of the man who stole it. Works by Cranach
and Bruegel, too, were victims of the same sad fate.

In November 2001 in a museum in Lucerne, Switzerland, a thief returned to the scene of an earlier crime—an error that brought to an end a dazzling series of art theft. Recognized by a witness, the criminal was arrested by the police: the art lover was accused of having stolen 239 art works from 174 different locations in the space of just six years. This young native Alsatian in his thirties is said to have begun stealing the objects of his passion in 1995. Visiting museums and European stately homes, he stole Cranach's outstanding *Sybille, Princess of Cleves* in Baden-Baden, a Bruegel in Antwerp, a painting by David Teniers from the museum in Cherbourg, another painting from the Royal Château de Blois, and many more art objects, statuettes, silverware, and jewelry. The artful criminal had thus created a fabulous private museum. Investigators were far from imagining that these thefts could have been the work of a single person; their theory

was that a gang must have been involved. So when he was arrested they congratulated themselves on having caught the perpetrator and on being able to return the art works to their original homes. But events took a turn for the worse: the thief's mother had destroyed the art that had been stored at her house. The objects had been thrown into a canal, and the masterpiece paintings had first been cut up then thrown into a garbage chute. The damage was estimated at several million euros.

Among the works that were irredeemably lost was François Boucher's *The Sleeping Shepherd*, stolen from Chartres museum in 1996. Boucher, an 18th-century painter considered a major Rococo master, was one of the first French painters to work on this open-air subject. All his life he painted landscapes, excelling in genre scenes known as pastorals.

François Boucher, *The Sleeping Shepherd*, 18th century, oil on canvas, 17 x 21 cm, stolen August 5, 1996, from the Musée des Beaux-Arts de Chartres, France

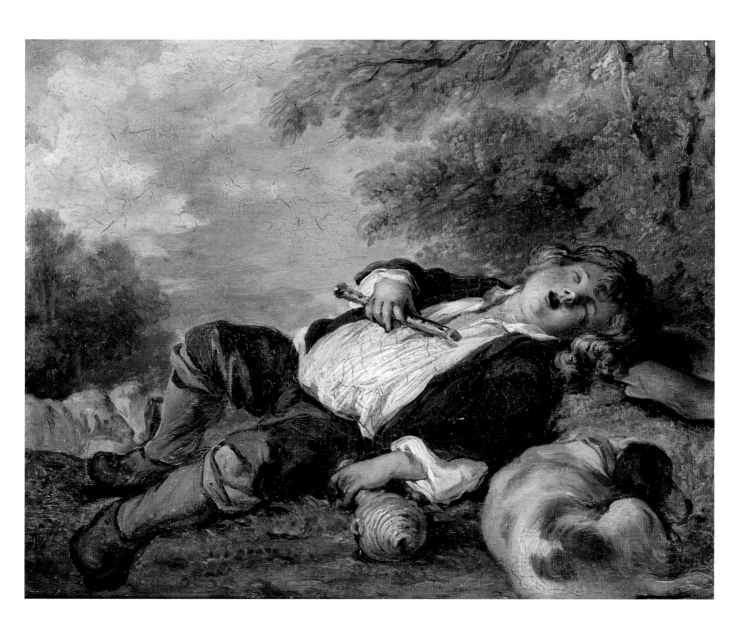

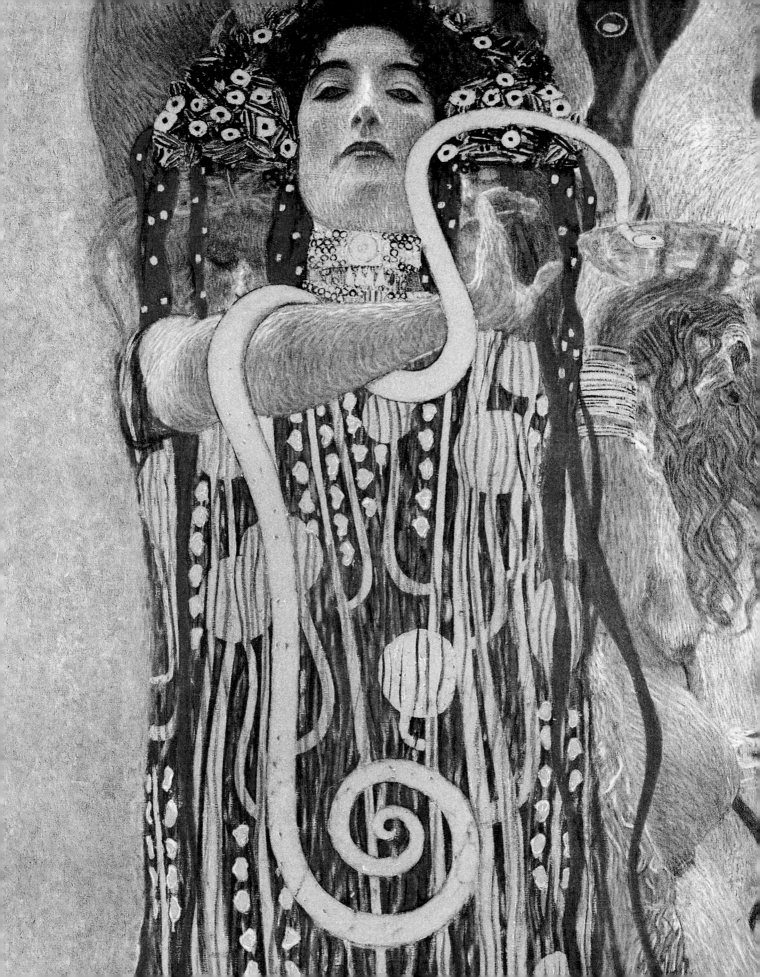

GUSTAV KLIMT
PHILOSOPHY

1862–1918

If the University of Vienna had not censored the commission given to the leader of the Secession movement, perhaps we would still be able to admire his work in the university's great hall. At least its fate would have been different.

In 1894 Gustav Klimt undertook to paint *Philosophy* for a decorative mural in the University of Vienna. Censored by its commissioners, this work was finally acquired by a private collector. However, during World War II it was confiscated by the Austrian state at Schloss Immendorf, and in 1945 the Nazi army set fire to the building. After having survived so many strokes of fate, *Philosophy* went up in smoke.

Gustav Klimt, *Hygieia* (detail from *Medicine*),
1900–1907, oil on canvas,
Kunsthistorisches Museum, Vienna, Austria

Gustav Klimt, *Philosophy*, 1899, oil on canvas, 430 x 300 cm, decorative panel for the Aula Magna of Vienna University, destroyed by fire 1945 at Schloss Immendorf, Austria

'To every age its art and to art its freedom' was the motto written above the entrance to the Vienna Secession building.

In 1894 the University of Vienna commissioned Austrian artist Gustav Klimt to decorate the ceiling of its great reception hall, the Aula Magna. Klimt, who was recognized for his talents as a decorative artist, created allegories of the three great university faculties: philosophy, medicine, and jurisprudence. But at this time Klimt was moving away from academic painting and, on the fringes of the official salons, in 1897 he founded the Vienna Secession. This association of artists advocated a spirit of openness towards the new artistic trends that were emerging all over Europe. At this time a struggle was taking place between institutionalized art and a free and personal creative practice. In this context it's not surprising that the sketches presented by Klimt in 1898 did not please the artistic committee of the academic institution. Far from depicting the glorious victory of knowledge and reason, *Philosophy* and *Medicine* were imbued with a visionary pessimism inspired by the philosophy of Arthur Schopenhauer and Friedrich Nietzsche, which went against the grain of the positivist spirit of the age. In *Philosophy*, a vertical chain of nude figures, stretching from birth to old age, eloquently expressed the fragility

and finitude of human existence. Despite the criticism and disapproval, Klimt exhibited the preparatory paintings of the work in 1900 during an exhibition at the Secession. That same year he received the prize for the best foreign work at the World's Fair in Paris. For its part, the university, shocked by what they considered the crude realism of *Medicine*, demanded that the nude figure be covered up or, if it had to remain nude, that the figure be a man rather than a woman. Klimt refused to change his paintings and in 1905 returned the advance he had been paid on the commission. This allowed him to continue working on the three paintings, which he finished in 1907, free of any hindrance.

Today all that remains of this work for the university is the sketch for *Medicine* that is in a private collection in Vienna. The other paintings, which were acquired by the collector August Lederer and finally seized by the Austrian state and placed in safekeeping at Schloss Immendorf, were destroyed during the last days of World War II. We know them only through black-and-white photographs and through a number of preparatory studies Klimt made.

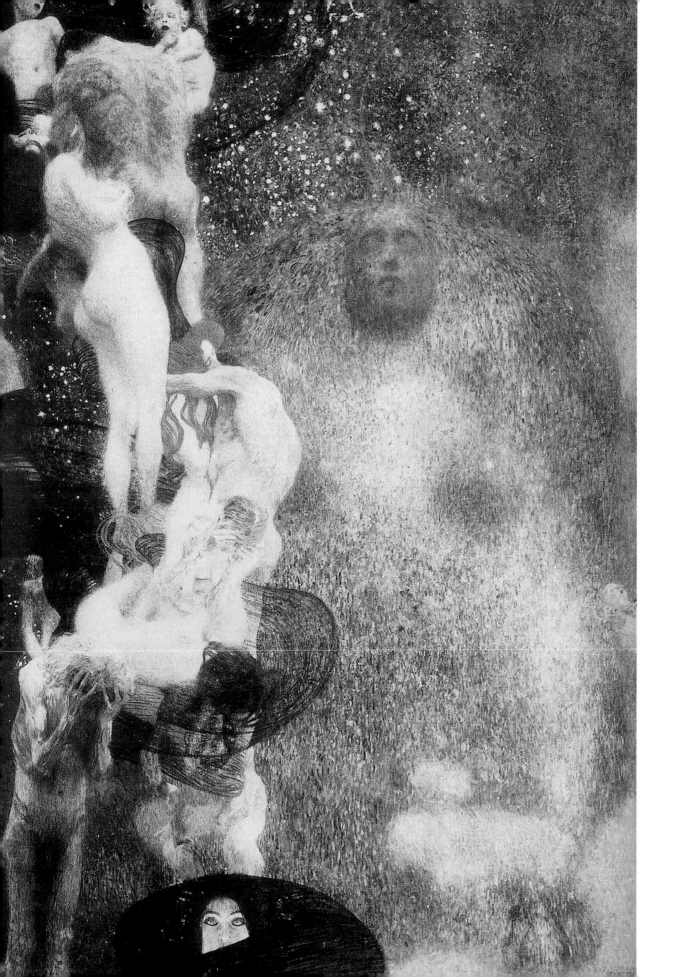

DIEGO RIVERA
MAN AT THE CROSSROADS

1886–1957

When the most famous American billionaire commissions art from a great Mexican artist who is also a militant Communist, what are the chances that the story will end badly? Censorship was inevitable.

In 1932 Diego Rivera was commissioned to paint a fresco for the entrance hall of one of the skyscrapers in the Rockefeller Center in New York. The mural paid homage to manual labor, and included a leading light of Communism—Lenin—an image that did not appeal to the Rockefeller family. Rivera's fresco was therefore removed, to be replaced by a fresco painted by another artist that was much more to the taste of the Rockefellers.

Diego Rivera's fresco covered with a cloth screen in the entrance hall of Rockefeller Center, 1933, New York.

For many long months in 1934, the authorities barred access to the entrance hall of the RCA Building before the fresco was finally destroyed, in a climate of—it has to be admitted—general indifference.

As a response to the stock market crash of 1929, the Rockefeller family built a spectacular architectural grouping in the heart of New York, the Rockefeller Center: five skyscrapers, an avenue, and plaza decorated with bas-reliefs, statues, and other works of art. This complex, dedicated above all to media and communication companies, was enriched with an artistic program inspiring an optimistic message on the theme of the progress of civilization. In this context it was not surprising that a fresco was commissioned to decorate the entrance hall of the most imposing skyscraper, the RCA Building. More surprising was the choice of artist—Diego Rivera, famous Mexican mural painter and member of the Communist Party. Pablo Picasso and Henri Matisse had been approached without success. In 1930 Rivera had just finished a mural at the Detroit Institute of Arts featuring scenes representing Detroit's industries, a work that might have influenced the Rockefeller family's decision. Whatever the case, in 1932 Rivera got down to work on his painting. But when scenes of May 1 in Moscow and a portrait of Lenin appeared on the 100-square-meter (1,076-square-feet) wall, controversy broke out. The Rockefellers demanded that Rivera replace Lenin's face; Rivera offered to add the face of Abraham Lincoln but refused to remove the Communist icon. So at Rockefeller's request the fresco was draped. Despite attempts to save the work, such as the idea of moving it to the Museum of Modern Art, the fresco was ultimately destroyed. Another artist was taken on, the Catalan José Maria Sert, who painted a mural depicting a vast allegory of men building modern America—and it included a portrait of Abraham Lincoln. As for Rivera, he went on to paint a modified version of *Man at the Crossroads* in Mexico, thanks to a photograph, which was taken in New York by his wife, Frida Kahlo. This version included a portrait of John D. Rockefeller, Jr.

Diego Rivera, *Man at the Crossroads*,
modified version of a fresco created in 1932
for the entrance hall of the Rockefeller Center,
which was destroyed 1934, 485 x 1145 cm,
Palacio de Bellas Artes, Mexico City, Mexico

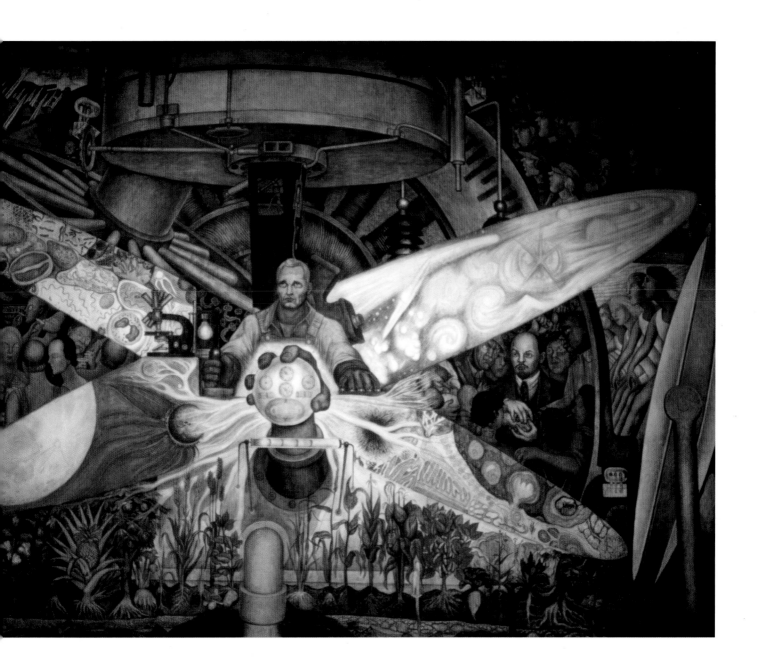

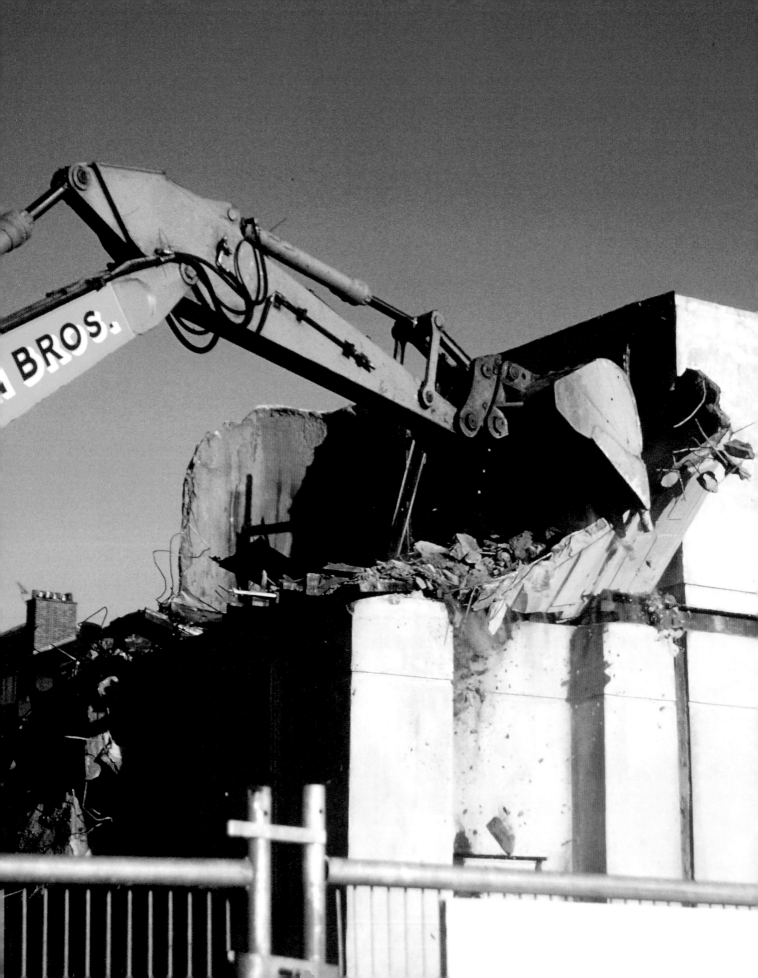

RACHEL WHITEREAD
HOUSE

1963–

Some works of art appear in the public domain like specters, full of memories of the past. But it seems that not everyone likes ghosts.

In 1993 the British artist Rachel Whiteread created a concrete cast of the interior of an East London house, a Victorian terrace property that she chose as an 'archetypal house.' This work of art was a kind of resurgence of the past that some people found disturbing. Officially opened on October 25, 1993, *House* was destroyed on January 11, 1994.

Demolition of Rachel Whiteread's *House*,
London, January 1994

Rachel Whiteread,
House, 1993,
concrete, destroyed 1994,
Grove Road, East London,
Great Britain

House was not able to hold out against its hostile opponents,

who had it destroyed in less than three months.

Rachel Whiteread's work is an art made of impressions and traces. Her first pieces were made by salvaging everyday objects that bear the traces of human life—bath-tubs, mattresses, second-hand chairs with hairs on them, and so on—wrapping them in fabric, then dipping them in rubber, wax, or plaster. The object is now unshakably linked to the life it has experienced. From 1990 onwards, Whiteread embarked on much larger-scale projects. For example, she created the plaster cast of the living room of a Victorian apartment, then she assembled the impressions of the four walls into a cube using steel frames. Looking at this ghostly work of art, which is indeed titled *Ghost*, viewers can experience a strange feeling: Whiteread sculpts empty space and displays what is real as a negative. In 1993 Whiteread pushed this process to its limits. She injected concrete into a whole, abandoned house, located on the corner of Grove Road and Roman Road in London. In this Whiteread was imitating the traditional process of the foundry-worker, but inverting the roles: the interior of the house, which is created by the laborer, not the artist, becomes a cast. After the cast was made, the real skin of the house was removed like a shell to reveal a monumental work of art. Whiteread's *House* bears material witness to a past that tries to take shape in the present.

House attracted crowds of visitors to this working-class area of London and aroused heated controversy, all the more so as Whiteread received the prestigious Turner Prize at this time. Some Londoners saw a subversive meaning in the sculpture. The work actually upsets a conventional relationship with the past; it embodies a return of the repressed that some people could not bear. Its detractors got the upper hand and *House* was destroyed several months after it was made. In 1996 Whiteread used the same principle to create *Holocaust Memorial A.K.A. (Nameless Library)*. Commissioned by the city of Vienna in Austria, this memorial to the Shoah was installed in 2000 on Judenplatz. Consisting of a concrete block formed from casts of bookshelves, this work once again fills a void to re-create the meaning of the past.

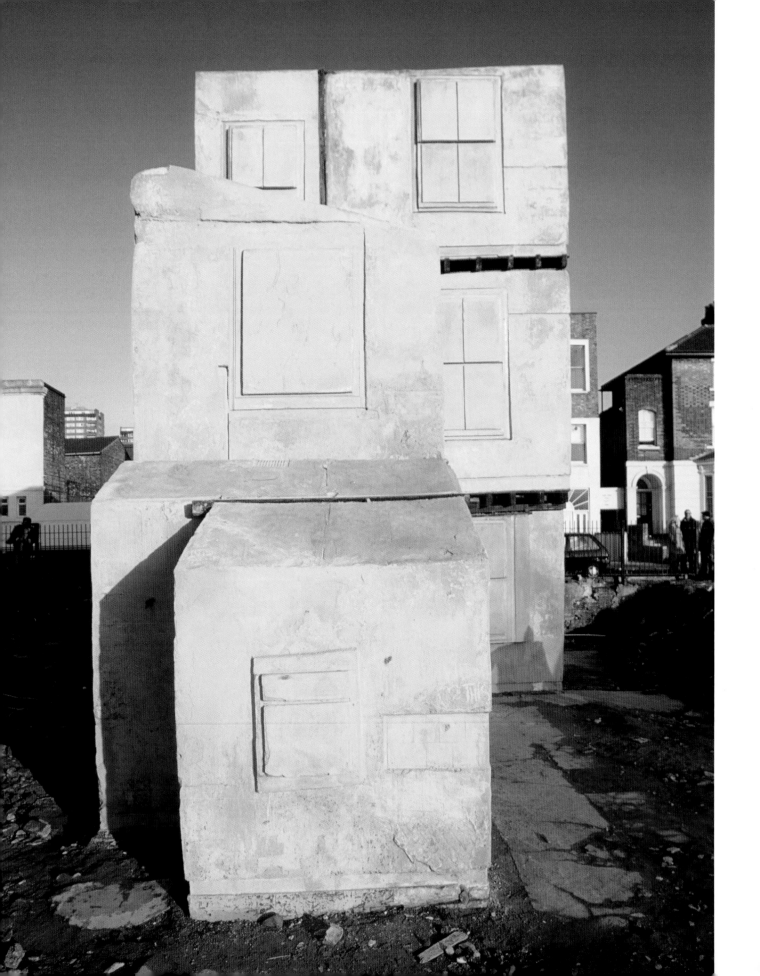

THE SAATCHI COLLECTION

May 24, 2004

On May 24, 2004, a fire devastated a warehouse in Leyton, a district in East London. The building belonged to Momart, a company specializing in the storage of works of art, whose clients included the National Gallery, Tate Modern, Tate Britain, Buckingham Palace, and Charles Saatchi. In the case of Saatchi's collection, around a hundred works of contemporary British art went up in smoke.

Clearly works of art cannot all be on show all the time. Museums' storerooms and certain specialist storage warehouses form a huge 'invisible museum' where works are not always immune from disastrous accidents.

The Momart warehouse after the fire, May 26, 2004, East London, Great Britain

At the end of 2004, Momart asked the Chapman brothers to design their Christmas corporate gift. As might have been predicted, the two artists, faithful to their spirit of provocation, decided irony was appropriate: they proposed a beautiful cigarette lighter stamped with the name 'Momart'!

The fire broke out in the early hours of the morning in an industrial estate in Leyton, and it took two whole days to bring it under control. The fire extended across an area the size of a soccer pitch. For Momart, it was indeed 'hell,' to name the title of one of the works that disappeared in the total destruction of the company's warehouse. *Hell* by Jake and Dinos Chapman was an installation of tiny Nazi figures engaging in massacres set in terrifying miniature landscapes, presented in nine small glass cases. This work, created in the year 2000, belonged to the Saatchi Collection, like most of the pieces destroyed in the fire. Since 1990 Charles Saatchi has been collecting works by YBAs (Young British Artists): the most famous of them, Damien Hirst, came to the fore in 1992 with his exhibition of a shark preserved in formaldehyde. Many of Hirst's paintings were destroyed, as well as some equally disturbing works by the young Tracey Emin, such as a camping tent with 200 names written on it—everyone the artist had ever slept with between 1963 and 1995, including her lovers and the names of the fetuses she had aborted. The list of works that were lost is long, and they were often the creations of the *enfants terribles* of the British art scene. For example, there was a work from the *Captain Shit* series, the name of the superhero invented by Chris Ofili in 1996, and also a painting by Gary Hume, pieces by Rachel Whiteread, and works by the duo Tim Noble and Sue Webster, among many others.

Tracey Emin, *Everyone I Have Ever Slept With, 1963–1995,* 1995,
tent, mattress, and light, 122 x 245 x 215 cm,
destroyed 2004 during a fire. Exhibited for the first time in 1995 at the
South London Gallery founded by Charles Saatchi, London, Great Britain

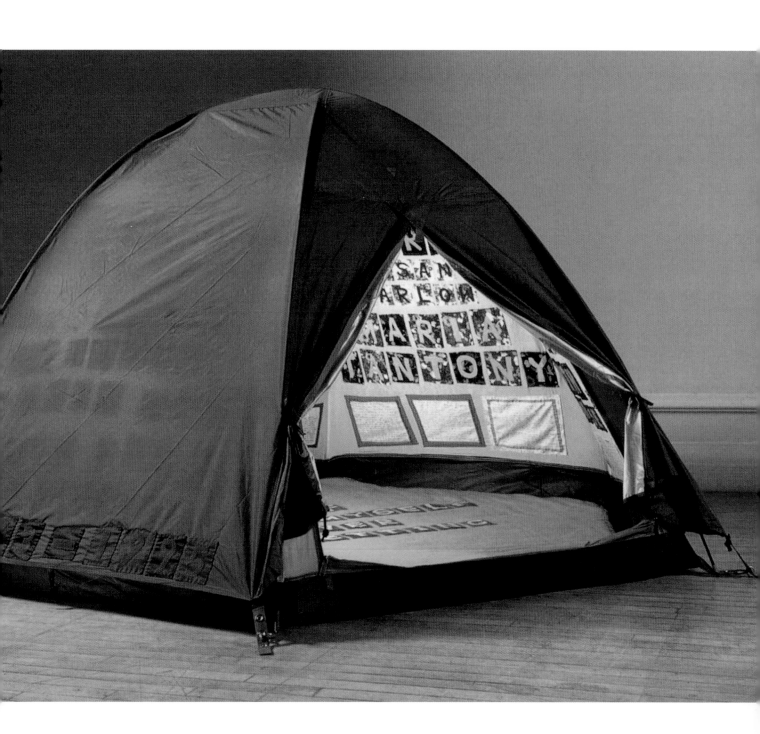

HIDDEN

There are some works of art that will never be publicly exhibited. They inhabit the intimacy of private spaces, set aside for the pleasure of a few privileged individuals. Even more depressing for the art lover, some private collections are kept in safes, far away from anyone's eyes, condemned to waiting for a new owner and an increase in market prices. Some works will never be known to us, others only through reproductions. If master-pieces happen to come to public auction and change hands from one collector to another, people become desperate to get hold of the catalogues in order to own at least an image of these unattainable beauties. The sale catalogue for the art collection of Yves Saint Laurent and Pierre Bergé, which was exhibited for just a few days at the Grand Palais in Paris in 2009, was published in an edition of 6,000 copies. Sometimes these catalogues have themselves become collector's items.

Today the most important players in the art market are the private collectors. In order to promote their collections, some of them have opened exhibition spaces. Frenchman François Pinault presides over two private museums in Venice, the Palazzo Grassi and Punta della Dogana, while in London Charles Saatchi, who already owns a gallery in the city, is planning to open a free museum there.

But the biggest 'private' museum in the world does not exhibit the works it contains: with its 140,000 square meters (over 1.5 million square feet) of warehouses protected by wire fencing, this is the free port in Geneva. The advantage of this enormous depository is that customs duty is suspended for the period of time that goods are stored there. It is said that the Swiss art dealer Pierre Huber conducts meetings with his clients at the free port. In Europe every great collector has his own vault in a free port. The Nahmad family, for example, is said to store 5,000 works of art at a free port, including 300 Picassos. When the family sold a Picasso at Christie's in November 2007 for 30 million dollars, they had kept the painting in a vault for 12 years. The Mugrabi family, who own 800 Andy Warhols, keep their treasure of more than 3,000 works of art in warehouses in New York and Zurich. In the suburbs of Basel, a gray concrete cube of 20,000 square meters (215, 218 square feet), located in an area populated with supermarkets, contains the collection of industrialist Emanuel Hoffmann. The austere Schaulager building opens its doors only to researchers and professionals. On the other side of the Atlantic, in New York, on the occasion of the Armory Show some major collectors offer open house to a few art lovers: it would seem that such a prestigious private visit does wonders for the market price of the works on show.

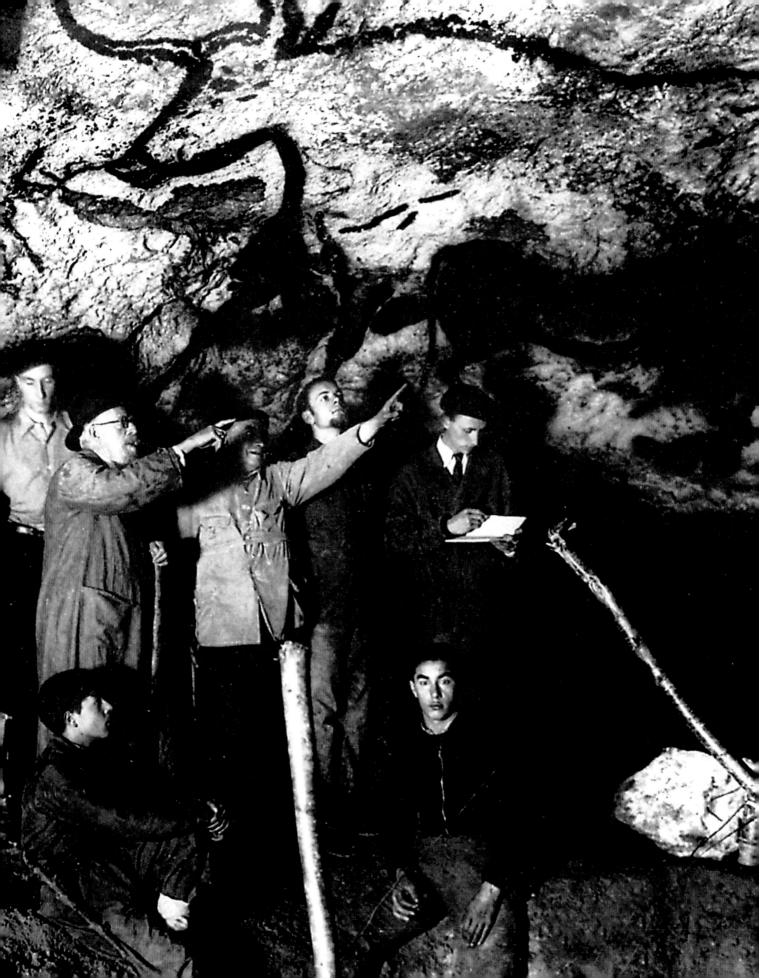

THE CAVE PAINTINGS AT LASCAUX

c. 15,000 BC

On September 12, 1940, in a forest in the Dordogne region of France, four teenagers on a treasure hunt came across a mysterious 'fox hole.' Thus a children's game revealed the existence of the Lascaux caves and their extraordinary gallery of prehistoric paintings.

First discovered in 1940, the Lascaux caves were opened to the public in 1948. In light of the sophistication of these wall paintings, many visitors had to abandon their prejudices with regard to 'cavemen.' However, the large number of visitors quickly endangered the masterpieces that date from around 15,000 BC. Since 1963 Lascaux has been off limits to the general public, who must make do with an identical replica cave, Lascaux II, which opened in 1983.

Abbott Henri Breuil (third from the right) in the Great Hall of the Bulls. Seated in front are two of the teenagers who discovered the cave, Jacques Marsal and Marcel Ravidat, 1948, Lascaux caves, Montignac, France.

The 'Fourth Bull' painted at Lascaux is still today the most imposing
work of wall art, extending as it does over more than five meters (nearly 17 feet).

More than 2,000 figures cover the walls and ceilings of Lascaux, depicting horses, bison, deer, and a rhinoceros. The spectacle is all the more moving since the palette of colors used was clearly limited and the nature of the cave walls did not make drawing the figures easy. Nevertheless, in the superb Great Hall of the Bulls, where the rocky surface did not permit carving, the paintings abound. The animal forms, outlined in black, are worked in velvety gradations of color, their artists having made the most of the mineral pigments and the light effects in the caves, which had to be lit by torches. Even if researchers disagree as to the purpose of these images, the works themselves clearly bear witness to the vital and intimate relationship between man and his art.

The closure of Lascaux was made necessary by concerns over conservation, for the discovery of the caves has disrupted their microclimate. From 1955 onwards condensation caused by visitors' breath was dissolving the paintings, and in 1960 infestations caused by algae in particular threatened the frescoes. This situation led to the closure of the site, which, since then, has been accessible only to people working or researching at the caves. The first years of the new millennium saw black and white stains, caused by molds, growing rapidly over the walls. As a result, in 2009 UNESCO placed Lascaux on the list of endangered monuments. Lascaux II allows visitors to enjoy this prehistoric miracle in replica. But like the original caves, Lascaux II receives hordes of visitors and now it too is deteriorating, making restoration of the replica necessary as well.

Reconstruction of a mural painting from the Lascaux caves
dating from the Paleolithic era, Montignac, France

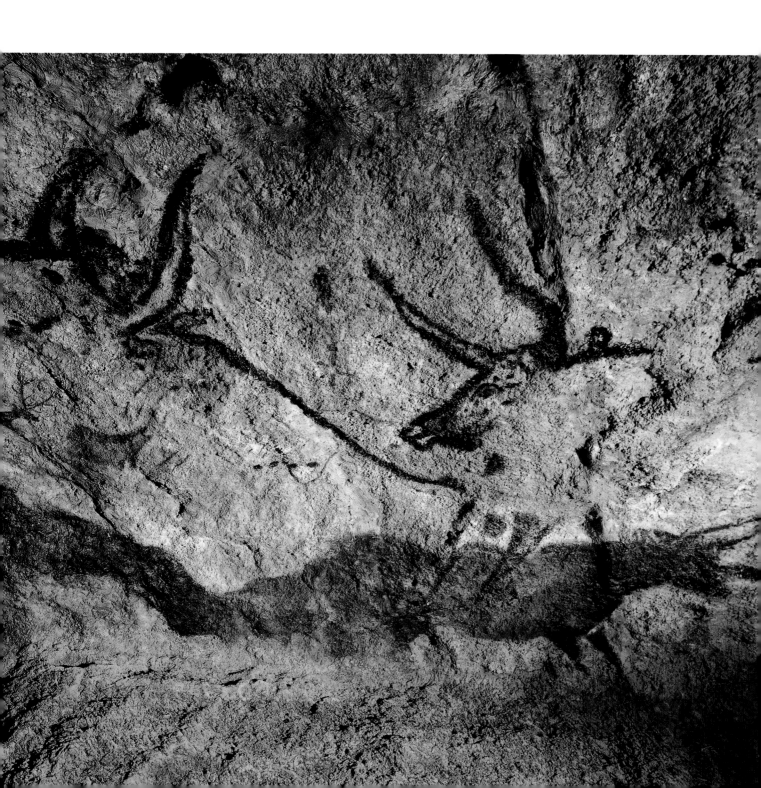

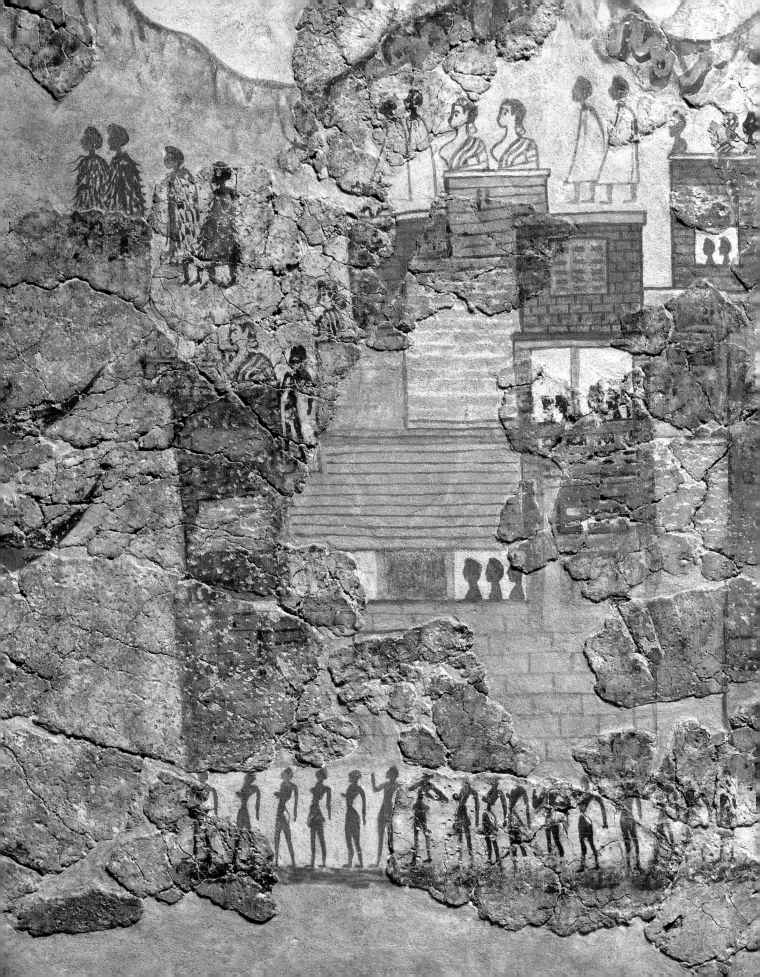

THE AKROTIRI FRESCOES, SANTORINI

c. 1500 BC

By a cruel paradox, the devastating eruption of a volcano made possible the discovery, over three and a half thousand years later, of the archeological site of Akrotiri in the Greek Cycladic Islands, in a state of unexpected preservation. This was evidence of a sophisticated prehistoric civilization that vanished around 1500 BC.

It was in 1870, during the mining of pumice stone from the island of Santorini destined for the building works on the Suez Canal, that the ruins of Akrotiri were discovered. An entire city was revealed, including some intact houses that contain superb frescoes. The name 'Prehistoric Pompeii' was given to this hidden treasure, which had been preserved thanks to the volcanic ash that had protected it for around 3,500 years.

Naval Parade, *c.* 1600–1500 BC,
fresco, height: 43 cm, The West House,
Akrotiri, Santorini, Greece

Women Gathering Saffron Flowers (detail),
c. 1600–1500 BC,
fresco, height: 230 cm,
Akrotiri, Santorini, Greece

The astonishing discovery of Akrotiri has led to many contradictory theories being put forward by archeologists. Some believed that Akrotiri is all that remains of the mysterious lost world of Atlantis.

Santorini today, with its whitewashed villages and blue domes, represents no more than a third of Thera, the island that existed during the Bronze Age. The end of Akrotiri was brought about by a volcanic eruption of such violence that it split the island in two.

By revealing the remains of this town, archeologists have been able to walk down paved streets lined with shops filled with earthenware jars and terracotta vases. The houses, built on two or three levels, were constructed with stone and wood staircases and with walls reinforced with half-timbering. This elaborate architecture hints at an advanced and prosperous society, an image confirmed inside the houses by the splendid frescoes that decorate the living rooms. Exceptionally well preserved, these murals depict a flotilla of boats with their crews, fishermen carrying fish strung together on lines, young boxers, and women gathering saffron flowers. A detail from one of the frescoes bears witness to a medicinal use for saffron, as it shows a woman treating her wounded foot with it. These frescoes share certain similarities with Minoan wall paintings, and this has led some archeologists to consider Thera a colony of the Minoan civilization that flourished on Crete, a neighboring island about 100 kilometers (60 miles) from Santorini. To other archeologists, by contrast, the uniqueness of these themes and the originality with which they were depicted indicates a creative independence, the guarantor of the island's autonomy. During the second millennium BC, prehistoric Santorini was one of the great civilizations of the Aegean, a rich meeting-point of influences at the heart of the Cyclades.

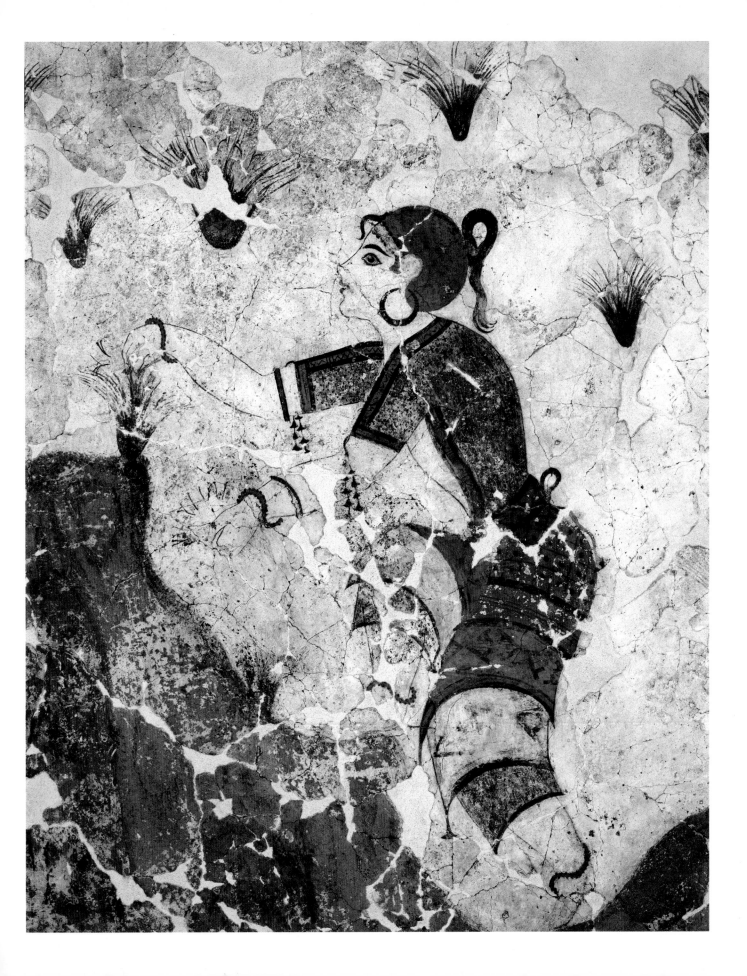

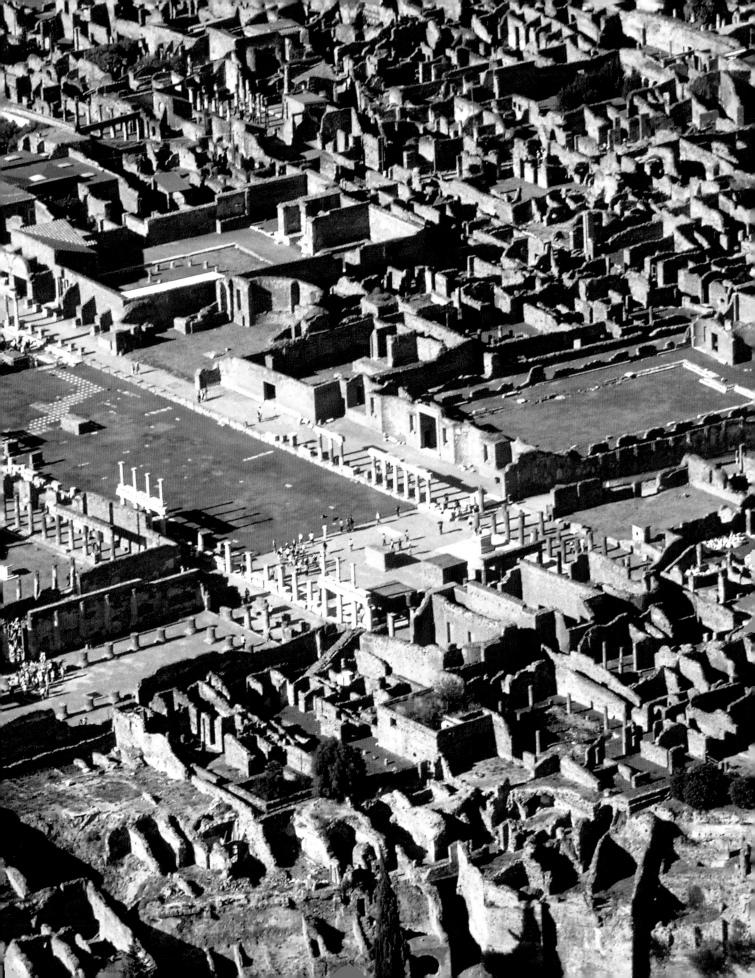

FRESCO IN THE HOUSE OF MARCUS LUCRETIUS FRONTO, POMPEII

2nd century BC

On August 24 in the year AD 79, Vesuvius erupted. In the space of several days the city of Pompeii was buried under a blanket of ash and pumice several meters deep. Paradoxically, this catastrophe has allowed us, centuries later, to get to know the art, technology, and customs of the victims of the volcano.

When they see the frescoes decorating the interiors of the houses, visitors to the ruined city of Pompeii might well regret living in the 21st century! In the house of Marcus Lucretius Fronto, which was excavated in 1899, the main scene in one of the frescoes shows a life of great sophistication, even if the Roman painter copied an original Greek image that has today been lost.

Aerial view of Pompeii, Italy

Fresco depicting a mythological scene,
house of Marcus Lucretius Fronto, Pompeii, Italy

For the Romans, making copies of original Alexandrian paintings on the walls of their houses, as if they were the originals, helped to emphasize their links with the glory of Greece.

Archeological excavations began in Pompeii in 1748, but almost half of the site still remains to be discovered. Gradually, archeologists have revealed the magnificent museum-like houses. The house of Marcus Lucretius Fronto was excavated at the very end of the 19th century, its owner identified by means of election notices painted in the streets and a graffito bearing his name. The house dates from the 2nd century BC, and is modest in size—just 460 square meters (4,950 square feet)—compared with other Pompeian properties. By contrast, its mural decoration is remarkable. The living room in particular is completely covered in frescoes. In the middle of one of the walls, decorative elements surround a scene featuring the courtship of Ares and Aphrodite, depicted in such a way as to give the impression of a painting hung on the wall. This is a famous story from Greek mythology: Aphrodite preferred handsome Ares, god of war, to her ugly and lame husband, Hephaestus. But the lovers were surprised by Helios, the Sun god, who then told the deceived husband. Hephaestus took his revenge by capturing the two lovers in a net and inviting all the gods of Olympus to see what they had done. This fresco, with its precious, brilliant colors, is one that stands out from the usual products of the workshops of Pompeian decorators, and it has been attributed to a painter who specialized in scenes from mythology. But this same fresco can also be found in another house in Pompeii, as it is a copy of a Greek original. In fact it is not unusual to find two identical paintings in different houses. In general they are by the same artist and were copied from Alexandrian designs that were passed around among decorators. Ultimately, this Roman habit of copying and collecting has given us the pleasure of discovering masterpieces of Greek painting that would not otherwise have survived.

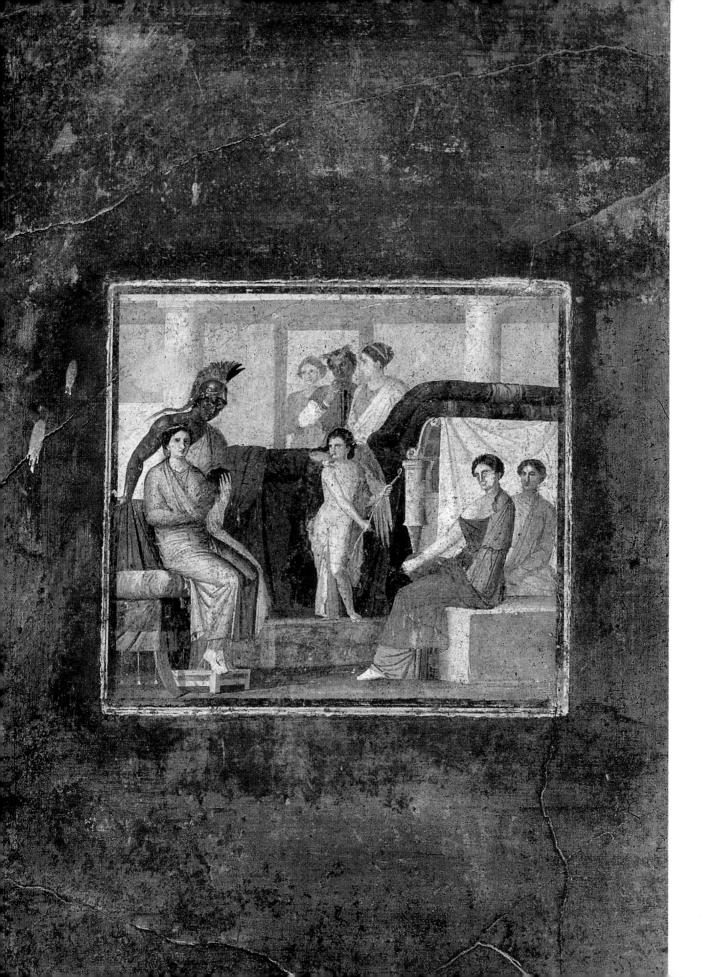

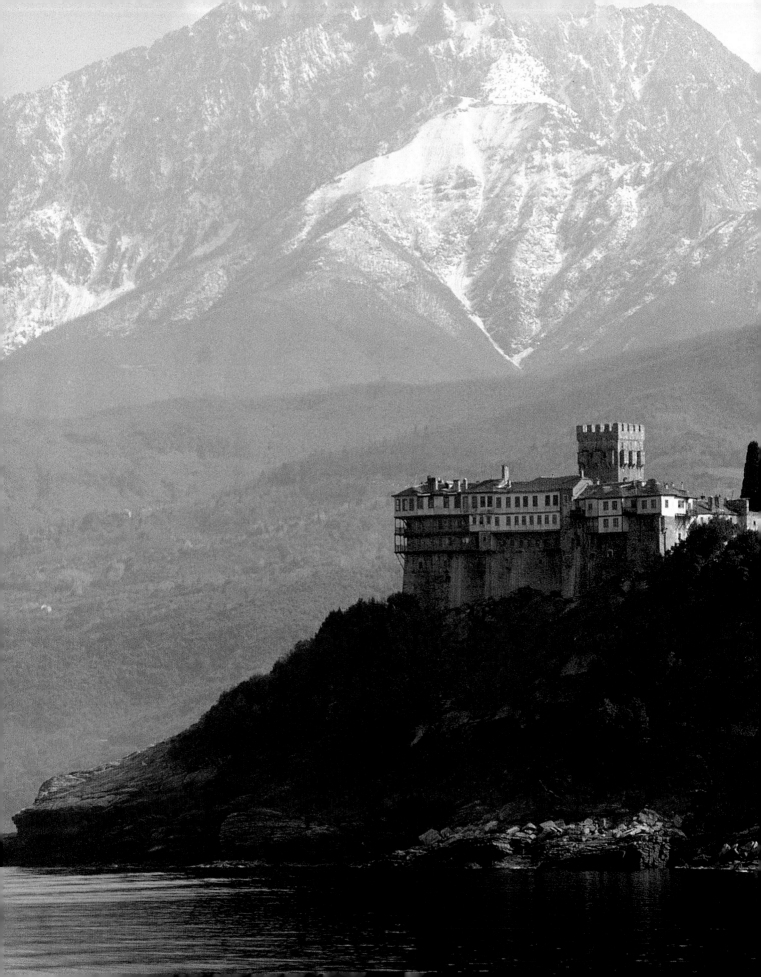

THE MOUNT ATHOS FRESCOES

For more than a thousand years, around 20 Orthodox monasteries have occupied the peninsula of Mount Athos. But to visit them, lovers of Byzantine art have to fulfill conditions that, happily, no museum has ever imposed.

After the capture of Constantinople by the Ottoman Turks in the 15th century, many Byzantine intellectuals, ecclesiastics, and artists took refuge on Mount Athos. The monasteries of the peninsula have retained amazing accounts of this event. But this monastic republic is intent on remaining an entirely separate world—it refuses access to women and also carefully limits visits by men.

Stavroniketa Monastery,
Monastic State of Mount Athos, Greece

'Mount Athos is prohibited to all female animals, all women, all eunuchs, and all beardless persons.' This law dating from 1045 is still enforced. Only hens managed to escape the rules, as their eggs were necessary to make the paint used in the icons.

With its extraordinary geographical location featuring dramatic cliffs, its monasteries that look like fortified castles sometimes clinging to the rocks, and its extraordinary artistic wealth, Mount Athos might seem to be a perfect destination for a holiday brochure. Except it's not easy to visit. Indeed, since the 9th century, the only inhabitants of Mount Athos have been Orthodox hermits and monks. Moreover, the peninsula maintains a political status, which was established by the Byzantine state, making it an autonomous regime on religious territory recognized by Greece's constitution. In order to visit the monasteries on Mount Athos, (male) visitors must submit a written request and obtain a special visa. Pilgrims flock there in their thousands, but there are very few tourists. On Mount Athos, life is still run according to Byzantine time and the Julian calendar: the two thousand monks, who are technically Greek by nationality, live in a separate time zone from that of Greece.

Twenty great monasteries occupy Mount Athos, mostly Greek, but also Russian, Serbian, and Bulgarian. These monasteries, which were mainly founded by Byzantine emperors in the 10th century, when the peninsula was already inhabited by hermits and ascetics, are pure masterpieces of medieval architecture and are decorated with remarkable frescoes and mosaics. Apart from the profusion of icons and other cult objects, there are precious and closely guarded manuscripts in the numerous libraries on Mount Athos. In recent decades, European grants have made possible huge renovation works and improvements to the monasteries. However, most of the works of art do not leave the Holy Mountain, though there have been two important exceptions: when they were exhibited in Thessalonika in 1997 and in Paris in 2009.

The Council of Constantinople,
1854, mural,
Great Lavra Monastery, Monastic
State of Mount Athos, Greece

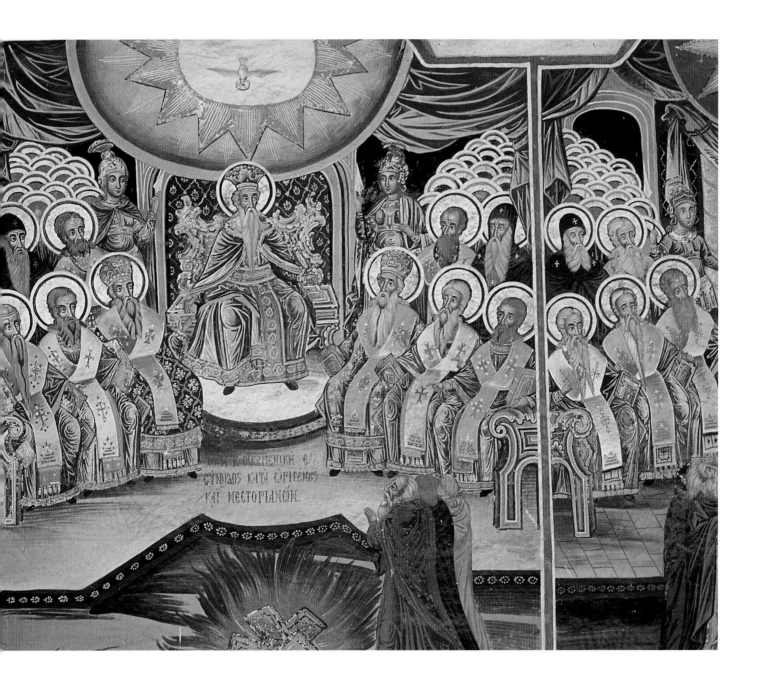

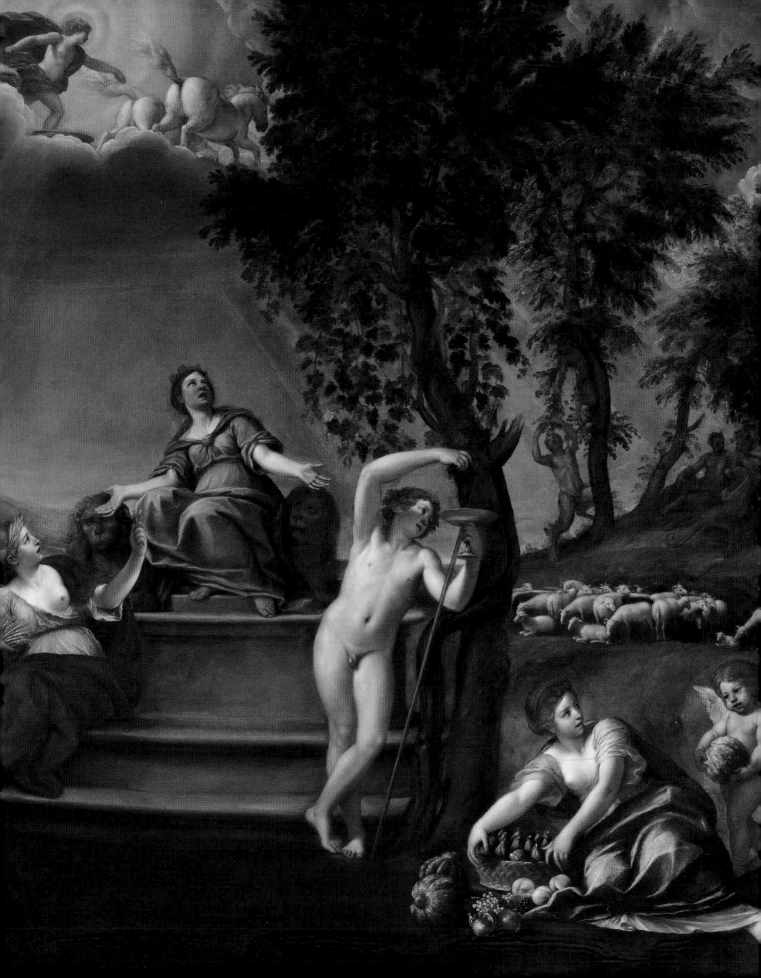

FRANCESCO ALBANI
THE ALLEGORY OF FERTILITY

1578–1660

According to French law, works of art that belong to national museums can be loaned provided they are accessible to the general public. However, this is not the case for the thousands of works that adorn the walls of private spaces in many public institutions.

One of Francesco Albani's masterpieces has been hung in the French Senate in Paris since 1853. Until 2010, the Louvre Museum tried on several occasions to retrieve this painting, even proposing to exchange it for a work in the Luxembourg Palace. After a heated debate largely conducted in the press, *The Allegory of Fertility* was finally returned to the Louvre. The public had to wait a little longer before seeing it, however, as it had to be restored.

Francesco Albani,
Cybele and the Seasons or *The Allegory of the Earth*,
1635, oil on copper, 85 x 103 cm,
Château de Fontainebleau, France

The Italian artist Francesco Albani, who was much appreciated

during his lifetime and collected by Louis XIV,

seems to have stirred up a lot of jealousy once again.

A decree issued in France in 1981 states that works of art loaned by national museums such as the Louvre must remain accessible to the public. In Paris, however, the Elysée Palace, the Senate, the National Assembly, and various ministries and city halls hold a great number of works of art that cannot been seen by those who are not invited to visit those places. In addition, it is not always guaranteed that these works are kept under adequate conditions of conservation and security. To retrieve the works that belong to them, national museums very often have to negotiate aggressively with borrowers who, when they accept to return their treasures, demand others in exchange.

For example, a painting by Albani belonging to the Louvre, *The Allegory of Fertility*, has been hanging in the Senate since 1853. Until 2010 it was kept in the private apartments of the Senate president. The Paintings Department at the Louvre had been asking for the return of the painting for about ten years without success—it even proposed another work by Albani as a kind of 'exchange of prisoners.' Of course the painting was loaned to exhibitions, but nothing justified its being kept most of the time for the pleasure of a privileged few—a situation that had been going on for more than a century.

While the Louvre was working to retrieve 'its' Albani, the Château de Fontainebleau was launching a fundraising appeal to acquire another work by the artist. In fact, the Château de Fontainebleau already held in its collections two paintings belonging to the same series, which it wanted to complete: *The Allegory of the Heavens* and *The Allegory of the Earth* were awaiting *The Allegory of the Sea*, which at the time was being sold in the USA. The fundraising drive by the Ministry of Culture, supported by private partners, enabled the purchase of this work, which was considered 'of major importance to France's heritage.' After a separation lasting three hundred years, these three paintings were once again reunited in 2009.

Francesco Albani,
The Allegory of Fertility, 1640,
oil on copper, 49 x 57 cm,
Palais du Luxembourg, Private Apartments of the President of
the Senate, on loan from the Louvre Museum, Paris, France

FRANCISCO DE GOYA
TIME AND THE OLD WOMEN

1746–1828

Needless to say there is a hidden image in this scene—the image the old women are looking at in the mirror, one that will always remain invisible to the viewer. On the other hand, we are now able to see behind the painting itself, which, it turns out, is masking another scene.

When Francisco de Goya painted *Time and the Old Women* in *c.* 1810–1812, Spain was being rocked by a war of independence fought against Napoleon's armies. An X-ray of the painting, taken nearly two hundred years later, revealed that it was obscuring another work: Goya, lacking materials during this period of upheaval, had painted over an anonymous 17th-century painting.

Francisco de Goya, *Time and the Old Women*, c. 1808–1812, oil on canvas, 181 x 125 cm, Palais des Beaux-Arts, Lille, France

First X-rayed, then analysed by the digital multispectral camera,

Time and the Old Women has still not revealed all its secrets.

In 1799, just as Napoleon was taking power in France, Goya was appointed Court Painter to the Spanish Crown. The following year he painted *Charles IV of Spain and his Family*, which focused on his Queen Consort Maria Luisa, and, in a discreet way, on her infidelities with Prime Minister Manuel de Godoy. At the same time, he published a set of prints, *Los Caprichos*, which cast a sharp and ruthlessly honest eye on human nature. One of the plates ridicules the affectations of women, a theme taken up again in 1810 in *Time and the Old Women*. Here too an old woman looks at herself in the mirror with an air of self-satisfaction, despite her cadaverous appearance. With excessive make-up, and dressed like a young bride, she also wears in her hair the famous 'diamond arrow' worn by the queen in *Charles IV of Spain and his Family*. So the painting is not limited to satirizing the vanity of aged coquettes; it also seeks to condemn Maria Luisa. From 1808, in the grip of a merciless war with the French, the whole of Spain placed responsibility for the defeat on the queen and her former lover, Godoy, a favorite of Napoleon. An enthusiastic defender of Spanish independence, Goya produced in this painting the equivalent of a newspaper column. This perhaps also explains his urgent need to find a canvas to paint the scene. Radiography of the work has revealed that Goya covered up a scene of the Ascension of Christ, painted by an anonymous artist in the 17th century. In 2008 the Musée des Beaux-Arts in Lille, France, which owns the painting, had it analyzed by a digital multispectral camera that captures a wider range of electromagnetic frequencies than just X-rays. This second screening process revealed the outline of a dog at the feet of Queen Maria Luisa that recalls the dogs in works by Diego Velázquez that Goya had closely studied: did Goya first cover the old canvas with a study that preceded *Time and the Old Women*?

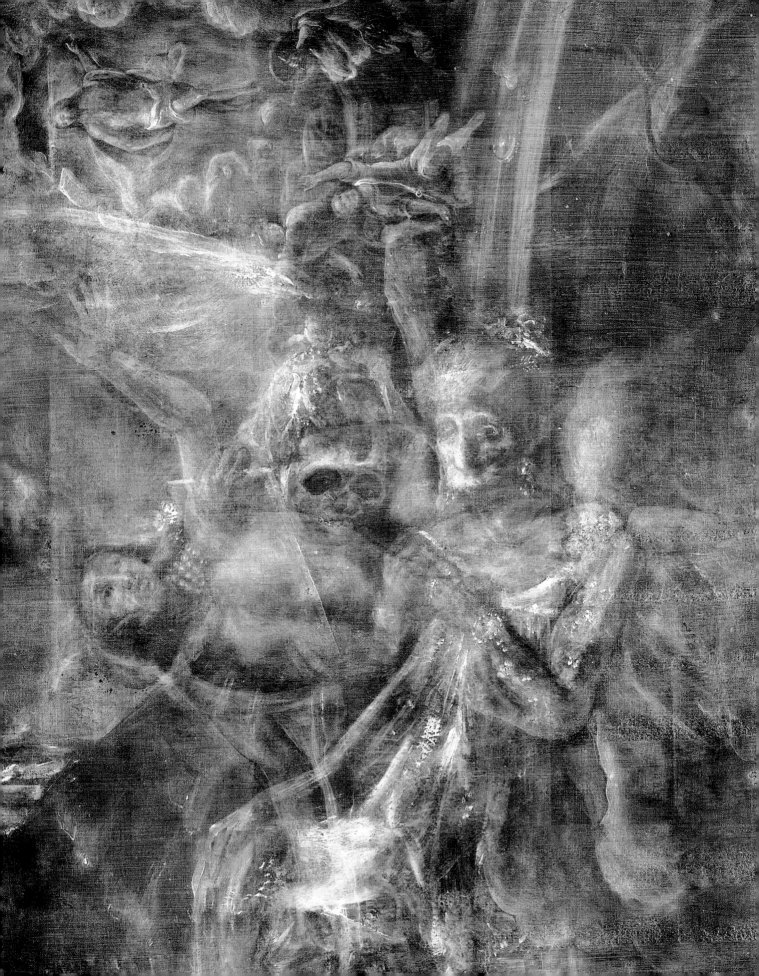

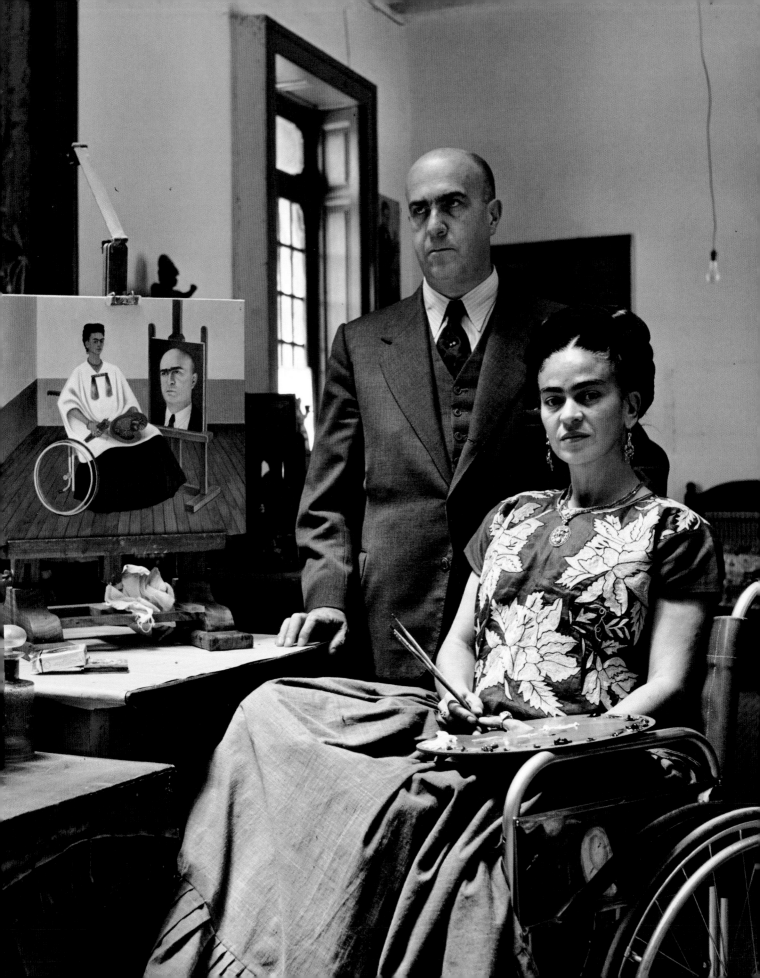

FRIDA KAHLO
SELF-PORTRAIT WITH THE PORTRAIT OF DOCTOR FARILL

1907–1954

The self-portrait occupies an essential place in the paintings of Frida Kahlo, as her body underwent a great deal of suffering throughout her short life. And when Kahlo chose to pay homage to her doctor, she painted a double portrait.

Self-Portrait with the Portrait of Doctor Farill could be likened to a 'private' work of art, destined for the patron who is represented in it, and for him alone. Indeed, the public is deprived of this work, as it was acquired by a private collection. But, through reproductions, the painting tells us a lot more about the role of art than about the personality of Doctor Farill. And thus is continues to be a part of the complete works of Frida Kahlo as much as the property of its lucky owner.

Frida Kahlo with her doctor, Juan Farill, Mexico, 1951,
photograph by Gisèle Freund,
Musée national d'Art moderne Centre Georges Pompidou,
Paris, France

In 1953, a year before her death, Frieda Kahlo had her first solo exhibition in Mexico. True to her formidable strength of character, she insisted on attending the opening of the show, carried there on her hospital bed.

In 1951 Frida Kahlo depicted herself once more, but this time alongside her portrait of Doctor Farill, the surgeon who had just operated on her. Kahlo underwent seven procedures on her spine in less than one year, and this was the first painting that she made on her discharge from hospital. It is a kind of thank you to 'the man who saved her,' as well as a homage to painting, for in this picture it is the artist who has the power to bring the doctor to life, the latter appearing through the means of painting. Kahlo's palette seems to be made from the artist's own body, from the very material of her suffering. It is art's revenge on life, which is the theme of Frida Kahlo's entire work. As the victim of a very serious accident at the age of 18, Kahlo was continually in and out of hospital, suffering its consequences throughout her life. She began painting when she was bed-bound, using a mirror hung from the bed canopy. She used her own reflection as a model and went on to produce a long series of self-portraits. In 1928 she joined the Mexican Communist Party and met the painter Diego Rivera, whose work she greatly admired. They became a legendary couple, their love affair bringing them together as much as their political engagement. In 1930 they left Mexico to live in San Francisco, where Rivera was to paint murals. Ten years later Kahlo returned to San Francisco for medical treatment, and there she dedicated a painting to her physician, *Self-Portrait Dedicated to Doctor Eloesser*. Thus *Self-Portrait with the Portrait of Doctor Farill* came to be an echo of this earlier work, 20 years later. The painting seems to derive its meaning in the context of Kahlo's lifelong artistic search. And this can heighten our sense of the cruel absence of those works that are kept in private collections. They elude not only the public, but also any possibility of our fully appreciating the artist's achievement.

Frida Kahlo, *Self-Portrait with the Portrait of Doctor Farill*,
1951, oil on panel, 41.5 x 50 cm,
Arvil Gallery, Mexico City, Mexico

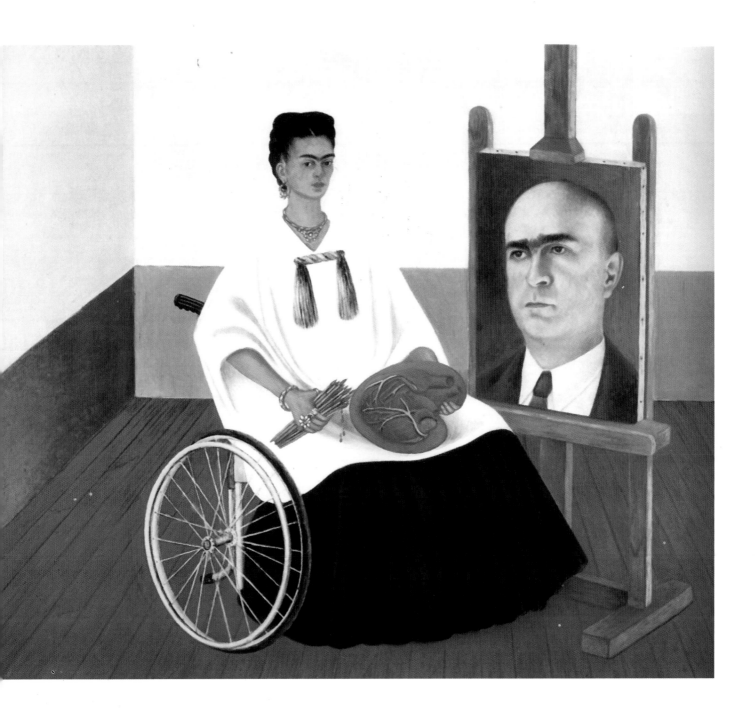

ALBERTO GIACOMETTI
WALKING MAN I

1901–1966

Some works of art spend their lives hidden away in private collections. If they change hands they might appear for a few moments on the occasion of auctions. Then, more often than not, they just disappear again.

Alberto Giacometti's *Walking Man I* is without question a major work of 20th-century art. One of the bronze editions has been traveling the planet since it was created in 1960, dependent on the goodwill of its various owners.

Art collector G. David Thompson examining a sculpture, 1959,
Photo: Yale Joel, Time & Life Pictures

One of the ten bronze editions of Albert Giacometti's *Walking Man I* reached
the record price of 65 million pounds (104 million dollars)
at Sotheby's in London on February 3, 2010.

In 1959 Alberto Giacometti received a commission from Chase Manhattan Bank. This was not enough to make him abandon the implacable demands of the ceaseless searching that characterized his career. In his tiny Paris studio, Giacometti worked on more than 40 versions of his *Walking Man*. In this piece he succeeded in representing not a man, but his essence, his truth. This highly emotional silhouette brought into focus ideas about existence, reality, and absurdity that were being explored in the writings of Jean Genet, Jean-Paul Sartre, and Samuel Beckett during the same period. It is also because it attains this universal, philosophical dimension that Giacometti's sculpture is a masterpiece.

The New York bank that finally cancelled the commission must have bitterly regretted their impatience. In 1961 the art dealer André Maeght was clever enough to buy an edition of *Walking Man I*, and Giacometti also gave him an artist's proof in plaster for the price of the cast: this unique work can still be seen at the Fondation Maeght in Saint-Paul-de-Vence, France. By contrast, Maeght very quickly sold the bronze edition to Sydney Janis, an American colleague. In 1962 Janis traded the work with the print dealer Isidore Cohen, who then sold it to a Chicago doctor called Milton Ratner. This collector managed to hold on to it until 1980, when financial difficulties forced him to part with it. Then Janis bought it back through a deal that was doubtless quite different from the one he had negotiated in 1962! Some months later, *Walking Man I* left the USA for Germany; it spent the next 30 years in the meeting room of Dresdner Bank, until the latter was bought by Commerzbank in 2008. Two years later, Giacometti's emblematic sculpture came up for sale at Sotheby's in London. Eight minutes on the telephone and *Walking Man I* disappeared once again, this time for the private enjoyment of a London-based billionaire.

Alberto Giacometti,
Walking Man I, 1960,
bronze, 182.245 x 26.67 x 96.52 cm,
Albright-Knox Art Gallery, Buffalo,
New York, USA

STOLEN

The theft of works of art has provided the subject for excellent detective novels and has inspired many movie screenplays. It is difficult to resist the charms of the gentleman thief, such as Thomas Crown, the art lover who stylishly steals a Monet from the Metropolitan Museum of Art in New York to relieve his boredom. But in the real world it is rarely the love of art that motivates the burglaries that feed a major illegal market. Churches and private homes are still the preferred location, and Pablo Picasso the preferred artist: today 600 works by the Spanish artist are missing. Recent posters on the 'most wanted works of art' circulated by Interpol show Picasso's *The Pigeon with Green Peas*, Van Gogh's *Broom and Red Poppies*, an icon stolen from a church in Macedonia, a sculpture missing from a New Delhi temple, a mummy pillaged from an archeological site in Cairo, and even a rare violin stolen from an apartment in New York.

The theft and trafficking of works of art is an international phenomenon that Interpol has been combatting since 1947 by trying to bring together governments and police forces around the world. Today there exists an online international database

listing thousands of stolen works of art. When they accept a work for sale, auction-house such as Christie's or Sotheby's must verify its provenance. But the traceability of these works is sometimes so well forged that it can deceive the best museum curators.

On an entirely different scale, the truly colossal thefts of artworks remain those that victorious countries inflicts upon their enemies. At the beginning of the 16th century, the Spanish *conquistadors* pillaged the art of the Incas. At the end of the 18th century, Napoleon's armies, during their Italian and Egyptian campaigns, appropriated those works that would sustain the future Louvre Museum in Paris. After the fall of Saddam Hussein in 2003, pillagers plundered Iraq's national museum, and the looting of archeological sites continues as a way of supporting a black market in antiquities—a trade that sometimes finances terrorist activities. But the most extensive and systematic of all these lootings remains that of the Nazis during World War II. Even today the seizure of Jewish assets demands an enormous amount of effort in the hope of returning them to their rightful owners.

ARRAS WORKSHOP
LIFE OF THE VIRGIN AND CHRIST TAPESTRY

1511

In France many tapestries, both medieval and Renaissance, are kept in sacred spaces rather than in museums. If these monumental hangings, woven with liturgical scenes, can be considered real works of art, they are most meaningful in the places for which they were created.

In the cathedral of Aix-en-Provence, France, the Life of the Virgin and Christ is played out across more than 30 meters (over 98 feet) of finely woven wool and silk. In 1977 several sections of this 'historic monument' were stolen. Created in Arras workshops in 1511, this tapestry has managed to survive the English Civil War and the French Revolution.

Interior courtyard of the Cathedral of Aix-en-Provence,
Aix-en-Provence, France

Looking rather like huge, deluxe comic strips, choir hangings were designed not only to tell a story, but also to protect those privileged churchmen who occupied the choir stalls in fine churches from draughts and the gaze of ordinary churchgoers.

The art of tapestry reached its peak in France and Flanders at the end of the Middle Ages and the beginning of the Renaissance. Tapestries were created to decorate and make more comfortable the grand, opulent residences of those who commissioned the works from the weavers' workshops. They were also used out of doors for secular celebrations, religious rites, and parades. In large sacred spaces, these tapestries gradually replaced the silk hangings that had been brought back from the Middle East by the Crusaders. Thus they became the bearer of religious scenes. The story to be depicted was devised by a man of the Church, and a painter worked up the scene and created the full-sized cartoons that were then passed to the weavers, whose work was considered the most important stage of the process; in other words, the signature on the work was that of its workshop. The tapestries were exhibited on important dates during the liturgical year and hung in the choir, the nave, and the sanctuary. The scenes depicted generally referred to the life of the patron saint of the building where the tapestry was to be hung, and a generous donor would sometimes be pleased to see his own portrait literally woven into the story of the patron saint.

The Life of the Virgin and Christ is a rare subject in this context. However, this was the story commissioned in 1511 from the Arras workshops for Canterbury Cathedral in England. This tapestry adorned the cathedral's choir until 1642, the date it left England because of the Civil War. Then it was bought for the cathedral of Aix-en-Provence in France, but it disappeared during the French Revolution. Well before 1789 the tapestries had been the victim of theft and ransom demands, by Protestants in particular. In 1802 the archbishop of Bordeaux bought the tapestry and bequeathed it in his will to Aix Cathedral. During its later turbulent history, the Life of the Virgin and Christ clearly went out of fashion, like other choir hangings, and several parts of it were lost. But it still deserves the status of 'historic monument' that was bestowed on it in 1898.

Arras Workshop, *Life of the Virgin and Christ Tapestry* (details): *The Nativity of the Virgin* and *The Annunciation*, 1511, low-warp tapestry, wool, and silk, Cathedral of Aix-en-Provence, France

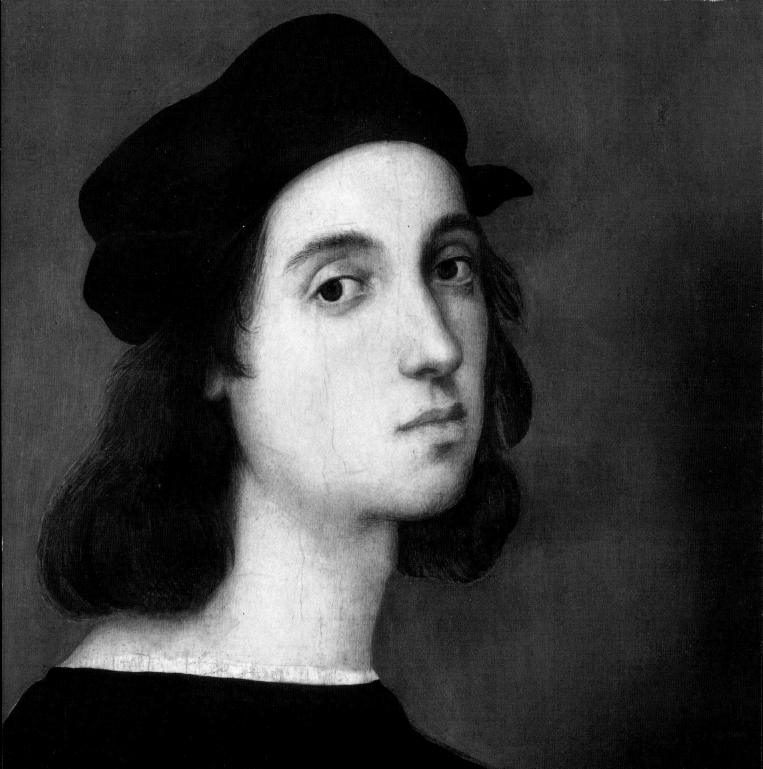

RAPHAEL
PORTRAIT OF A YOUNG MAN

1483–1520

Art historians do not agree on the attribution of the paint-ing *Portrait of a Young Man* to Raphael, but some do consider it to be a self-portrait by the painter. In the absence of the painting itself, however, it's hard to decide.

Since it was painted in 1513, *Portrait of a Young Man* has had an eventful career. After being acquired by a rich Polish family at the beginning of the 19th century, the painting continually succeeded in escaping the conflicts that shook Europe, until it was disastrously seized by the Nazis during World War II.

Raphael, *Self-Portrait*, 1506,
oil on panel, 45 x 33 cm,
Uffizi Gallery, Florence, Italy

Raphael, *Portrait of a Young Man*, *c.* 1511, oil on panel, 72 x 56 cm, commandeered in 1939 from the Czartoryski Museum, Krakow, Poland

A victim of Nazi looting in 1945, *Portrait of a Young Man* is still being sought by the Polish authorities.

In 1513, at the age of 30, Raphael, having worked in Florence at the same time as Leonardo da Vinci and Michelangelo, had already acquired a dazzling amount of experience. Recognized as a master, he was summoned from Florence to Rome to work for the Vatican. On his death, only seven years later, the admiration that his work aroused gave him the honor of being buried in the Pantheon in Rome.

Though the *Portrait of a Young Man* is not signed, it was certainly because they considered it a self-portrait by Raphael that the Czartoryski family bought it from Venetian private sellers around the year 1800. Thus the painting arrived to adorn the walls of the Czartroyskis' main residence in Puławy, Poland, alongside numerous other choice works such as Leonardo's *Lady with an Ermine*. In 1830, when a popular uprising occurred in Krakow, the aristocratic Polish family set up home in Paris, and transformed the Hôtel Lambert into a veritable Polish political and cultural center. Of course their paintings collection made the journey too: thus *Portrait of a Young Man* remained in Paris for around 40 years with the exception of a small sojourn in London during the 1848 Revolution. In 1876 the painting returned to Poland for the opening of the Czartoryski Museum in Krakow. This respite would be short-lived, however. At the outbreak of World War I, the painting was sent to Dresden in Germany along with part of the collection. This safety strategy worked and the painting was picked up again safe and sound in 1920. By contrast, in 1939, while it was being sent in a crate inscribed *VRR* (Vinci, Raphael, Rembrandt) to the palace in Sieniawa, the Czartoryskis' other residence, it was seized by the Nazis. It could then be seen in the Berlin museum before returning to Poland, but as part of the collection that the Nazi governor Hans Frank had awarded himself. In 1945 Frank fled the Red Army and sent his paintings to Germany. But since then the whereabouts of *Portrait of a Young Man* has remained unknown.

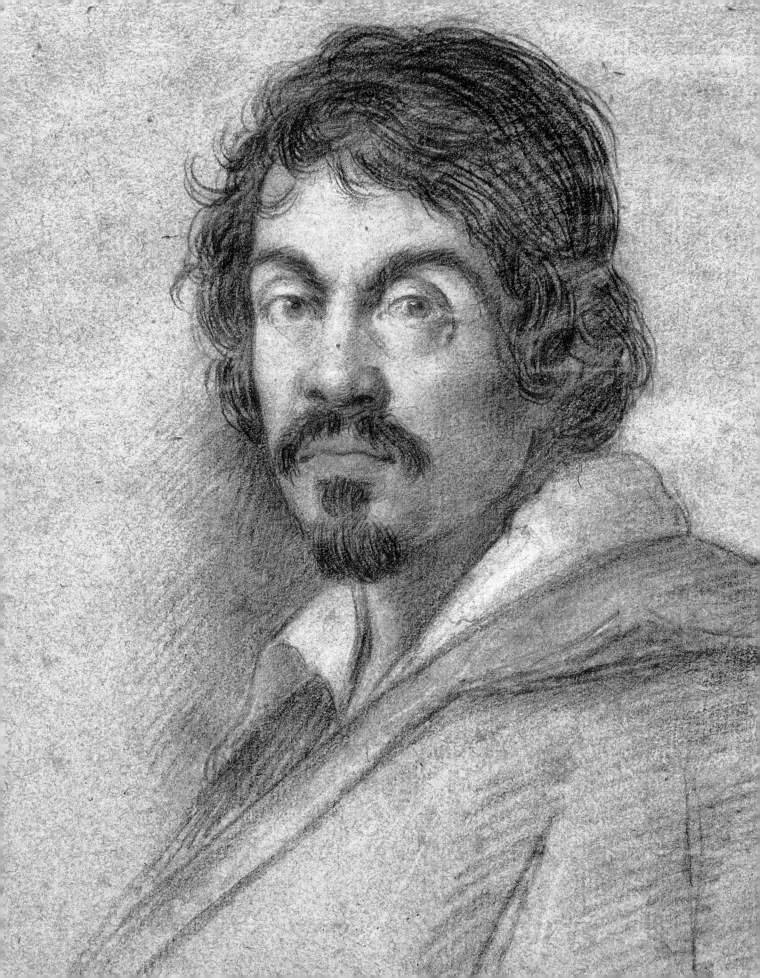

CARAVAGGIO
NATIVITY WITH ST. FRANCIS AND ST. LAWRENCE

c. 1571–1610

Admired for the daring realism of his religious scenes, Caravaggio became more famous in a tragic way at the end of his life. Suspected of murder, he was on the run from Italian justice until his death. Three centuries later it was one of his paintings that became the victim of Mafia crime.

In 1969 in Palermo, Sicily, Caravaggio's *Nativity with St. Francis and St. Lawrence* vanished from the Oratory of San Lorenzo. Inquiries to recover the stolen master-piece are still ongoing, despite a recent theory that it was destroyed in a fire.

Ottavio Leoni, *Portrait of Caravaggio, c.* 1621,
red and white chalks, charcoal on blue paper, 23.4 x 16.3 cm,
Biblioteca Marucelliana, Florence, Italy

Caravaggio, *Nativity with St. Francis and St. Lawrence*, 1609, oil on canvas, 271 x 198 cm, stolen October 17, 1969, from the Franciscan Monastery in Palermo, Italy

Some people believe that the painting was destroyed in an earthquake in Naples in 1980, while others tell of an Italian collector in South Africa.

The *Nativity with St. Francis and St. Lawrence* was painted in 1609, a year before Caravaggio's death. The large canvas was undoubtedly the masterpiece of the oratory of the church of San Francesco in Palermo. Its disappearance in 1969 seems to have encouraged other crimes: furniture with marquetry in mother-of-pearl and precious woods, and works from the 16th and 17th centuries vanished one after another.

Italian churches acquired numerous works of art during the 17th century. When the authority of the popes was endangered by the spread of Protestantism, the Catholic Church required artists to produce its propaganda images. Thus Caravaggio carried out important commissions that overturned the concept of religious painting, giving sacred scenes all the appearance of everyday reality. The theatrical lighting of his monumental compositions clearly did not fail to move the faithful. His style was copied throughout Europe, though the Church refused several canvases that were considered impious.

Of course these works would no doubt be better protected within the confines of a museum, but their meaning is closely linked to the sacred spaces for which they were originally intended. Improvements have been made at the Oratory of San Lorenzo to make the building more secure, which will perhaps help to bring the spate of art thefts to an end. It seems that the enquiry into finding the Caravaggio that was stolen in 1969 has not been abandoned. Since 1996 the justice system has known that the burglary was committed by the Mafia on behalf of an unknown buyer who refused the damaged painting. In Rome in 2008, during another trial, a Mafia *pentito* (informant) declared that the work had been accidentally destroyed in a fire. As far as Italy's Art Work Protection Unit is concerned, however, the painting still exists. Around one hundred letters formally requesting assistance have thus been sent to Japan, to the USA, and to many European countries. One rumor claims that the painting reached South Africa, where it was exchanged for diamonds.

JAN VERMEER
THE CONCERT

1632–1675

In 1903 in Boston, Isabella Stewart Gardner built a copy of a 15th-century Venetian palace to house her art collections. And once upon a time, in one of the museum's galleries, one could enjoy a small intimate scene painted by Vermeer.

On the night of March 17/18, 1990, the Gardner Museum's Vermeer disappeared. *The Concert* is considered the most famous of the paintings that were stolen. With three Rembrandts, and drawings by Edgar Degas and Édouard Manet, the spoils were valued at around 500 million dollars.

The Isabella Stewart Gardner Museum in 2009, Boston, USA

Owning a Vermeer is in itself something of a miracle: only 35 paintings have today been attributed to the artist with any certainty.

Jan Vermeer's career mirrored the atmosphere of his paintings—intimate, provincial, conscientious. His reputation did not extend beyond the boundaries of Delft, the town where he was born. He worked to commissions from private individuals, carefully taking his time. His paintings were rediscovered in the middle of the 19th century by one French art critic in particular: Théophile Thoré-Bürger championed Vermeer and acquired several of his works, including *The Concert*, which was completed shortly before the painter's death in 1675. As always, it was artists too who joined in the recognition of one of their equals: Pierre-Auguste Renoir, Vincent van Gogh, and then Salvador Dalí paid homage to Vermeer, like Sir Joshua Reynolds before them, and, more recently, even Robert Rauschenberg.

It was between 1894 and 1896 that Isabella Stewart Gardner bought *The Concert*, while she was scouting around Europe to add to her personal collection; around the same time, she also acquired Botticelli's *The Tragedy of Lucretia*, Titian's *The Rape of Europa*, and a Rembrandt *Self-Portrait*. These treasures joined the 2,500 works in the museum, which was designed specifically for them in 1903. But today there is no longer a Vermeer at the Gardner Museum.

On the night of March 17/18, 1990, criminals disguised as police officers took advantage of the St. Patrick's Day celebrations to break into the museum. After tying up the two night watchmen, they carefully made their choice from the collections and took down 13 works: the Vermeer, *The Storm on the Sea of Galilee* (Rembrandt's only known landscape), but also, more curiously, five drawings by Degas. An hour and a half later, they left the building. The private detective who tracked down Edvard Munch's *The Scream*, stolen in Norway, suspected a much-sought-after criminal who would thus have an excellent way of exerting pressure if he had been arrested on other charges.

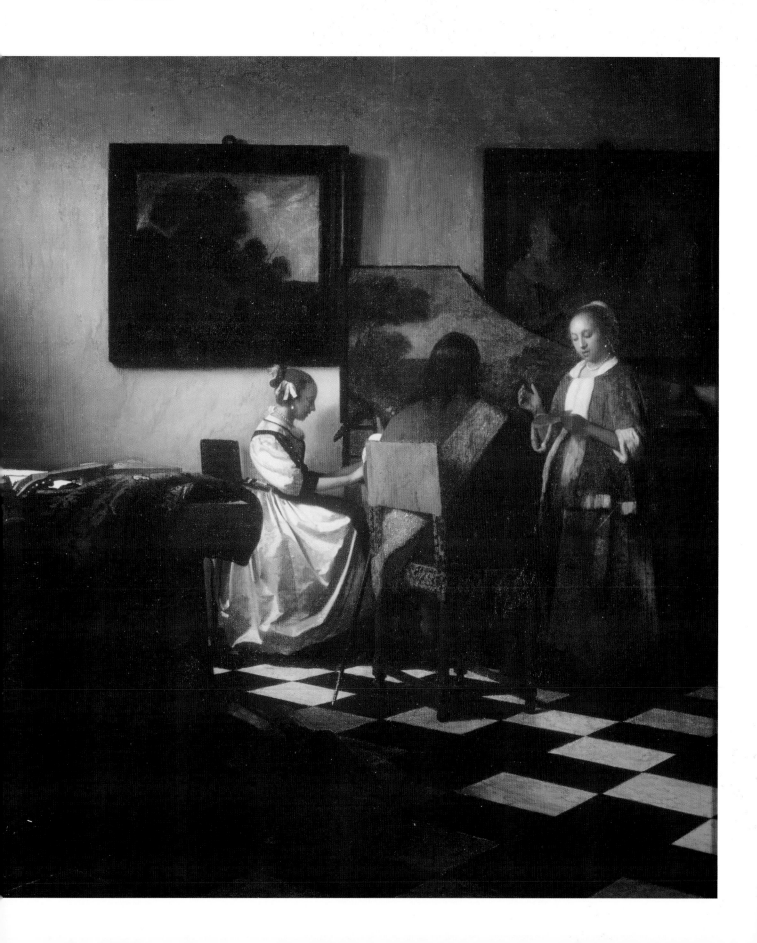

ANTONIO STRADIVARI
THE DAVIDOFF-MORINI STRADIVARIUS

1644–1737

Antonio Stradivari, the 18th-century Italian artisan, is still the most famous violin-maker in the world. Is it the wood, the form, the construction, or the varnish that creates the extraordinary quality of the instruments he made? Whatever it is, his violins are still passionately treasured by their owners—and with good reason.

In October 1995 the Stradivarius belonging to the Austrian violinist Erica Morini disappeared from her home while she was in hospital. The 'Davidoff-Morini Stradivarius' made in 1727, had belonged to Morini since 1924, when her father had given it to her. Valued at 3.5 million dollars, the instrument still appears among the FBI's most wanted works of art.

Edgar Bundy, *Antonio Stradivari at Work in his Studio*, 1893, oil on canvas, 35.5 x 52 cm, private collection

A few centimeters of carved wood that produce a unique sound unique:
there are nearly 600 Stradivariuses in circulation in the world,
some owned more legally than others.

Erica Morini's Stradivarius was taken from her Manhattan apartment quietly, apparently without a forced entry. Several months earlier, another Stradivarius was stolen from a Rolls Royce parked on a New York street. This recalls the theft of the Stradivarius that the virtuoso Pierre Amoyal had just put in his Porsche as he came out of a concert in Italy: the criminal escaped before Amoyal's very eyes, driving off in the sports car and taking the precious instrument with him. Traumatized by his loss, Amoyal did everything to regain his Stradivarius, and after four years he succeeded. He even published a book about it, a detective story for music lovers.

For connoisseurs, a Stradivarius represents more than just a simple violin. Each Stradivarius has its own personality, and the more famous ones have even been given a name linked to their history or their owner. The instrument stolen from the Italian musician Alberto Bianchi is called 'Colossus,' from the fact of its larger-than-average dimensions. Stradivariuses never cease to stir up greed throughout the world. In 2010 British police arrested three people to question them about the disappearance of the violin belonging to violinist Min-Jin Kym. She was eating in a café while waiting for a train at London's Euston Station when she took her eyes off her Straduvarius for an instant. Even more recently, in the spring of 2011, a very famous Stradivarius, the 'Lady Blunt,' was sold by Tarisio Auctions. This violin, made in 1721, belonged to Anna Blunt, granddaughter of the poet Lord Byron. It was bought for a record price of 15.9 million dollars. This sale was made all the more emotional as the proceeds were donated to a fund set up for the relief of victims of the tsunami that had just hit Japan.

Erica Morini with her
Stradivarius in 1942

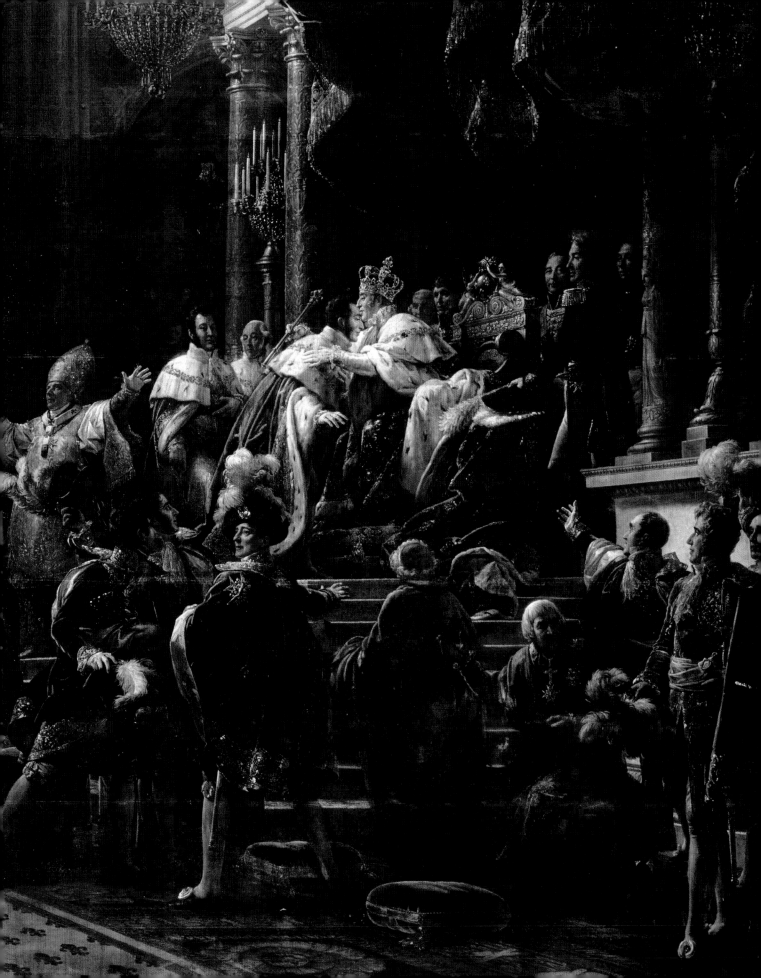

JACQUES-ÉVRARD BAPST
CHARLES X'S CORONATION SWORD

1771–1842

Charles X was the last French sovereign to be crowned in Reims Cathedral in May 1825. The painting that immortalized this scene suffered damage during the revolution of 1830. The French people had little appetite for this return of the absolute monarchy of the *ancien régime*.

At daybreak on December 16, 1976, three masked burglars broke into the Louvre Museum in Paris by taking advantage of the scaffolding that had been erected to clean the building's façade. From the glass cases they chose Charles X's coronation sword. Were these thieves fans of symbols of monarchy? That is unlikely, given that the sword was encrusted with 1,576 diamonds, which have doubtless been recycled for other purposes.

Baron François Pascal Simon Gérard,
The Coronation of Charles X at Reims, c. 1827,
oil on canvas, 514 x 972 cm,
Petit Trianon, Palace of Versailles, France

One can still see in the Louvre Museum the coronation sword known as
the sword of Charlemagne or 'Joyeuse,' a much less glittering example than
the sword of Charles X, but one that is much older.

While Louis XVIII refused to be crowned, his successor, Charles X, resumed the tradition. Preparations for the ceremony involved huge expense: the restoration and decoration of Reims Cathedral, the commissioning of an opera composed especially for the occasion, and even a royal carriage designed by an architect, a sculptor, a decorator, and a painter. In such circumstances the coronation sword had to pass muster. The jeweler to the French crown, Jacques-Évrard Bapst, was given the job. For the occasion it was decorated with a sheath embellished with fleurs-de-lys. In 1821 Bapst had designed a diadem that Louis XVIII had given to his niece, the Duchess of Angoulême. This masterpiece of Restoration jewelry is kept at the Louvre, who bought it in 2002. In the 'Diamond Case' of the Apollo Gallery, another Bapst creation, this time much more discreet, was worn by Charles X—a small enameled gold pendant in the shape of an elephant, the insignia of the Order of the Elephant, which the king wore to show his alliance with Denmark.

Since the opening of the Louvre Museum in 1793, the French crown jewels formed part of its collections. Three years later the treasure of the Cathedral Basilica of St-Denis, including the coronation regalia of the kings of France, was added. These are the chivalric accessories that Charles X had 'updated' for his own ceremony. The creation of the luxurious sword for his own coronation was the ultimate nostalgic gesture by an absolute monarch who believed in the divine right of kings. It was a gesture that was not well received by a society that had been profoundly changed by the Revolution.

Jacques-Évrard Bapst, *Charles X's Coronation Sword,* 1825,
1,576 diamonds of different sizes, black leather sheath,
diamonds, engraved gold, stolen December 16, 1976, from
the Louvre Museum, Paris, France

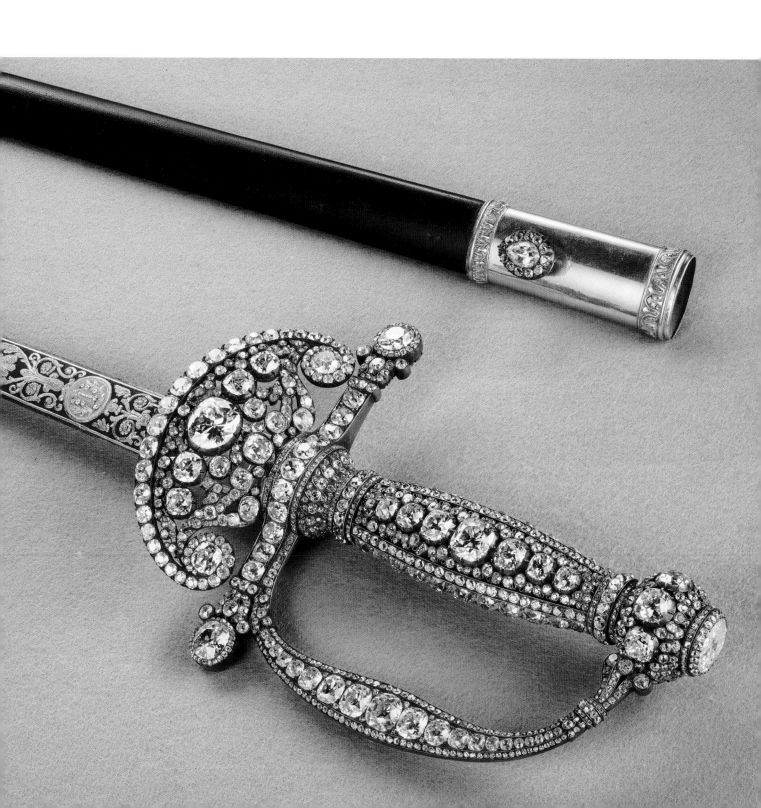

PAUL CÉZANNE
THE BOY IN THE RED WAISTCOAT

1839–1906

When Paul Cézanne recognized himself as the character of the wretched painter in a novel by his friend Émile Zola, he was so hurt that he broke off contact with the writer. If Cézanne understandably hoped for another outcome, he certainly could not have imagined that, a century later, his paintings would fetch such prices that they provoked robberies and hold-ups.

The acerbic jeers that greeted works by the Impressionists and later the Cubists now seem hollow in light of the astronomical prices that the paintings by these avant-garde artists reach today. An example of art at the crossroads between these two movements, Paul Cézanne's *The Boy in the Red Waistcoat,* stolen in 2008 in a manner worthy of an action movie and until very recently, it remained one of Interpol's most-wanted works of art.

Paul Cézanne, *Portrait of the Artist, c.* 1873–1876,
oil on canvas, 64 x 53 cm, Musée d'Orsay,
Paris, France

At the beginning of the year 2000, on New Year's Eve itself, another Cézanne painting was stolen from the Ashmolean Museum in Oxford, England. The owner of the painting, Oxford University, had neglected to insure the work (valued at almost 6.5 million dollars), preferring to focus on the reliability of the museum's security systems.

One Sunday in February 2008, towards the end of the afternoon, three unusual visitors entered the Foundation E.G. Bührle in Zurich, Switzerland, a museum famous for its major collection of Impressionist paintings. Three minutes later, hooded and armed, the criminals left the scene weighed down with a Monet, a Degas, a Van Gogh, and a Cézanne, all simply snatched from the walls. This was precious loot but extremely bulky, to the extent that some witnesses saw the paintings sticking out of the open trunk of the getaway car.

With an estimated value of 146 million dollars, however, these four works were much too famous to be put back on the market, and as if to prove this the Van Gogh and the Monet re-surfaced a few weeks after the theft, dumped in the parking lot of a Zurich psychiatric clinic.

As for *The Boy in the Red Waistcoat,* it was found in Belgrade in April 2012 thanks to the efforts of a buyer who was prepared to pay the thieves three million Euros, and it was to be returned quickly to the Foundation Bührle. The painting's homage to color recalls the ideas of the Impressionists: what one perceives, what one feels in the perception of a subject, outweigh an academic representation dependent on the logic of perspective and a respect for proportions. Moreover, one can already see, in the treatment of shapes, the method invented by Cézanne himself: 'Treat nature in terms of the cylinder, the sphere, and the cone.' This rule would be recalled by Georges Braque and Pablo Picasso when they invented Cubism, and would be quoted enthusiastically by the famous sculptor Alberto Giacometti as fundamental to 20th-century art.

Paul Cézanne, *The Boy in the Red Waistcoat, c.* 1880–1890, oil on canvas, 80 x 64.5 cm, stolen February 1, 2008, from the Foundation E.G. Bührle in Zurich, Switzerland

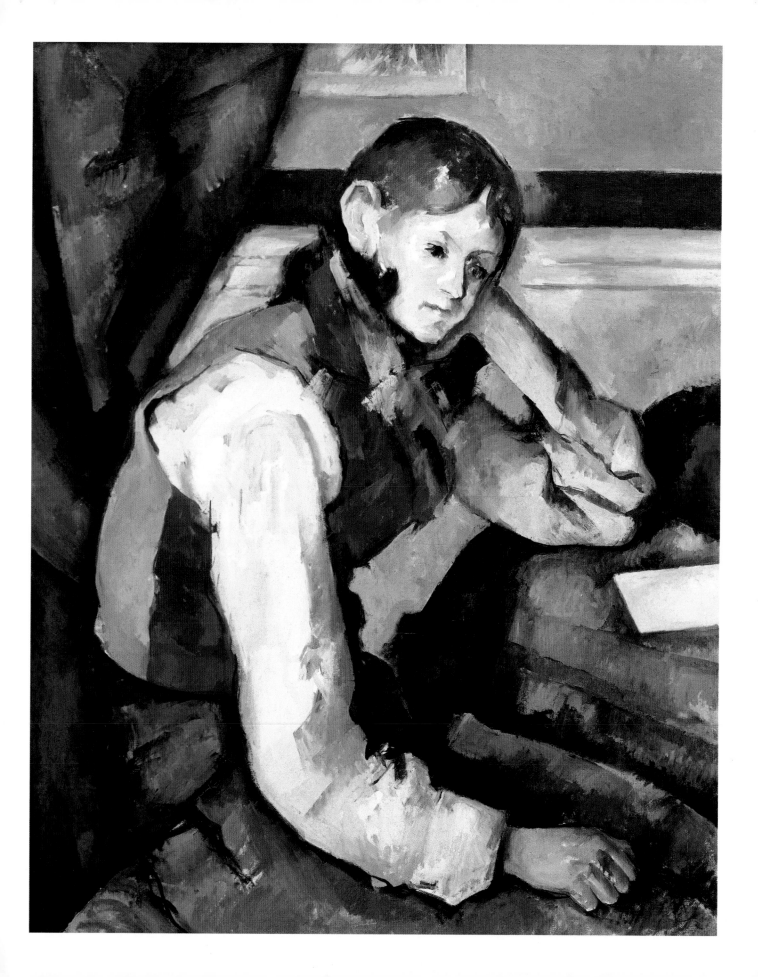

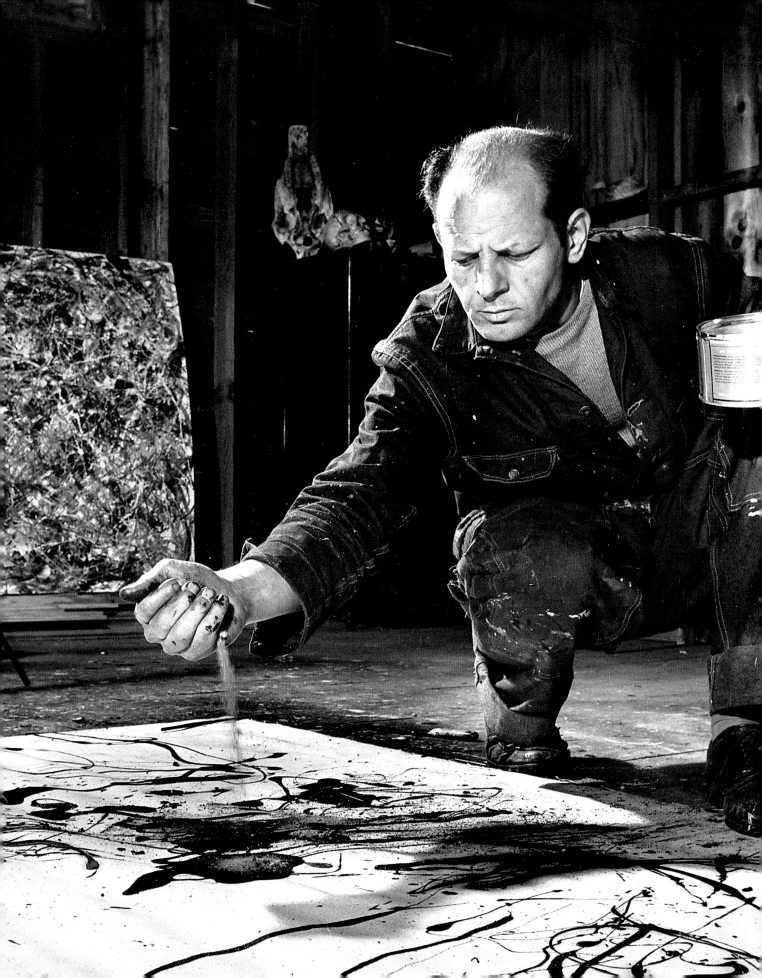

JACKSON POLLOCK
SPRINGS WINTER
(OR WINTER IN SPRINGS)

1912–1956

From 1943 onwards, Jackson Pollock almost exclusively painted using the techniques of splashing, pouring, and dripping paint. These works, associated with the movement called Abstract Expressionism, today reach dazzling prices at auction.

On the night of November 18, 2005, some visitors entered the Everhart Museum in Scranton, Pennsylvania, uninvited. They left with a painting by Pollock and a silkscreen print by Andy Warhol. The FBI is still looking for these two works.

Jackson Pollock working in his studio, 1949,
Photo: Martha Holmes, Time & Life Pictures

In 2006 a painting by Jackson Pollock, *No. 5, 1948*, was bought in
a private sale for a record price of 140 million dollars.

Painted in 1949, in 1951 *Springs Winter* was bought for 800 dollars. The Andy Warhol silkscreen print, *Le Grande Passion*, valued at around 100,000 dollars, belonged to the Everhart Museum of Natural History, Science and Art, a small museum in Scranton, Pennsylvania. By contrast, the Pollock had been on loan since 2003 from a collector, a Scranton artist who wanted to share his property with the public and also (ironically) to make it safer. *Springs Winter* was not included in the *catalogue raisonné* of Pollock's works, was not insured, and the museum's closed-circuit television cameras were not working on the night of the theft. The local police, who had a tricky case on their hands, must have been relieved when the FBI took over; they intervene in cases of art theft when the works are valued at a minimum of 100,000 dollars. The Pollock, because of its date and size, could have been valued at around ten million dollars.

In 1949 Jackson Pollock settled in The Springs, a small village in East Hampton in New York State. The stolen painting, *Springs Winter*, doubtless owes its name to the place where it was created. Pollock had set up a makeshift studio in a barn. Here he would be photographed, then filmed, by Hans Namuth, hard at work. Through his many 'physical' experiences with canvas and painting materials, Pollock had a profound influence on 20th-century art. From 1947 he worked on canvas that he unrolled on the floor, without a predetermined frame, thus creating what art critics went on to call 'all-over painting.' He poured the paint onto his canvas, and let it drip from his brush. This 'pouring' and 'dripping' turned his painting into a practice that was both abstract and spontaneous at the same time, in direct contact, it was claimed, with the artist's unconscious.

The FBI's Internet page showing
the wanted poster for *Springs Winter*

National Stolen Art File

Get FBI Updates

Home • About Us • What We Investigate • Violent Crime & Major Thefts • Art Theft • NSAF • Springs Winter

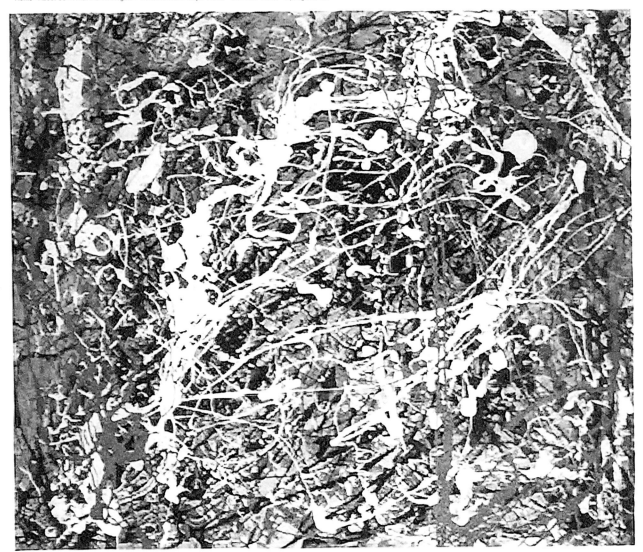

- **Description**: Stolen
- **Category**: Paintings
- **Maker**: Jackson Pollock
- **Materials**: oil on canvas
- **Measurements**: 40 x 32 in
- **Period**: 1949
- **Additional Information**: painting abstract unknown

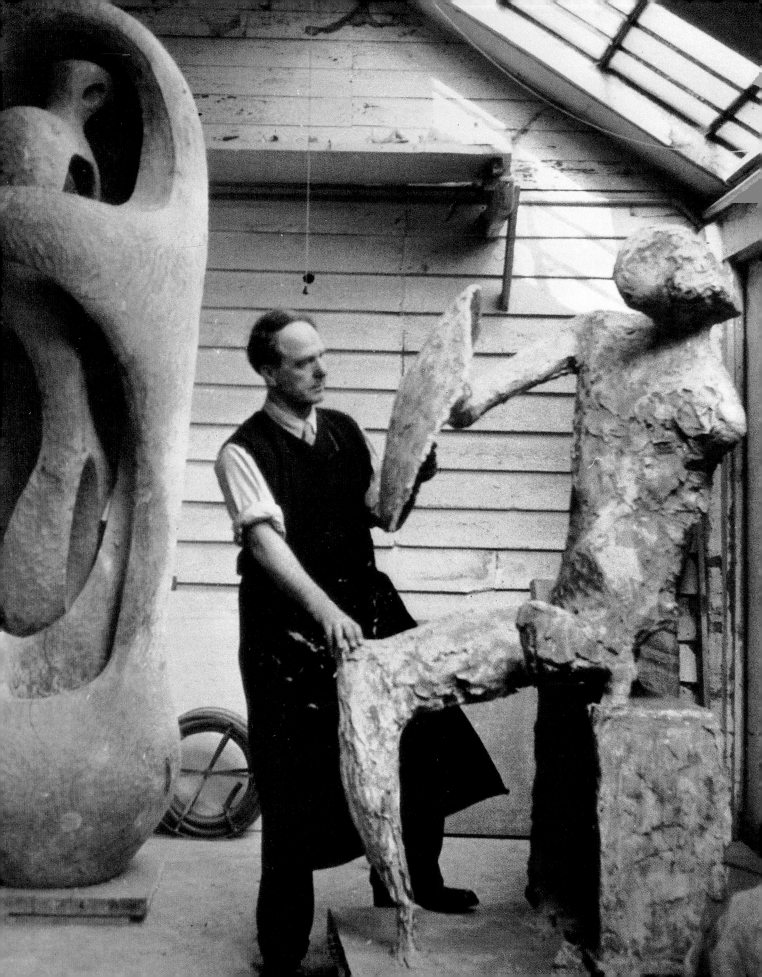

HENRY MOORE
RECLINING FIGURE

1898–1986

From the 1950s onwards, Henry Moore received numerous commissions for public sculptures, many of which are today still exhibited in outdoor spaces throughout the world. But however monumental these sculptures may be, they have not failed to arouse private passions.

In 1977, ten years before his death, Henry Moore created a foundation for the promotion of art. Located in the countryside north of London, Perry Green is also the place where many of the sculptor's works are kept and conserved. It was here that one of his *Reclining Figures*, a work measuring almost 4 meters (13 feet) in length and weighing more than two metric tons, was stolen on December 15, 2005.

Portrait of Henry Moore by a British photographer, 20th century

When this two-ton sculpture was stolen, the British press speculated that it might have been taken for the scrap value of the metal.

Henry Moore worked on the theme of the reclining figure throughout his career. As a young artist he had been inspired by Pre-Columbian statues representing an outstretched figure, head turned to the side, and holding a tray over its stomach. In 1925 at the Louvre Museum in Paris, Moore discovered a plaster reproduction of such a statue. The head of the figure is generally tiny, and this draws attention to the monumentality of the body. As in the art of the Surrealists, the female body was turned into a landscape. But Moore developed his figures in a more abstract way, working with space to sculpt the forms. His sculptures are fascinating because they continue into space, integrating the empty space around them and turning the space itself into a material. Their flowing, organic curves combine harmoniously with nature. Henry Moore's works seem made to live outdoors—which sometimes puts them in danger.

During the night of December 15, 2005, at Perry Green, in the quiet grounds of the Henry Moore Foundation, the *Reclining Figure* was stolen. Just back from an exhibition in Brazil, the work had been temporarily stored outside the protected areas. Closed-circuit television cameras revealed that the abduction took no more than ten minutes. The sculpture was lifted by a crane and placed on the back of a truck, and was thus spirited away. Several days later Hertfordshire police found the vehicle and the crane that had been stolen for the heist but, of course, their load was missing. The possibility that the bronze had been sold by weight was at first considered, but enquiries made to the local scrap merchants turned up nothing. There remained the theory that it was a theft sponsored by a private collector. The sculpture was valued at over 6 million dollars. There are six other bronze editions of the *Reclining Figure*, and three of them are on display in museums in Tel Aviv, Denmark, and Japan.

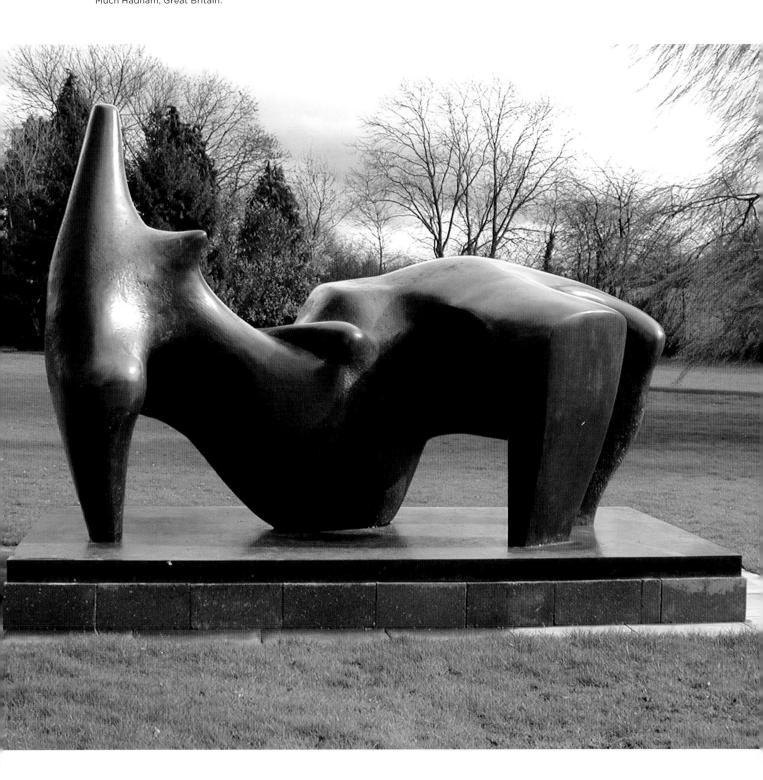

Henry Moore, *Reclining Figure*, 1951, bronze, 200 x 360 cm, stolen December 15, 2005, from the Henry Moore Foundation, Much Hadham, Great Britain.

INDEX OF ARTISTS

Page numbers in **bold** refer to illustrations

PHOTO CREDITS

tl: top left | bl: bottom left | tr: top right | br: bottom right